Tīfaifai and

Quilts of Polynesia

Tīfaifai and
Quilts of Polynesia

JOYCE D. HAMMOND

 University of Hawaii Press ◆ Honolulu

97 96 95 94 93 92 6 5 4 3 2

LIBRARY OF CONGRESS CATALOGING-IN-PUBLICATION DATA

Hammond, Joyce D., 1950–
 Tīfaifai and quilts of Polynesia.

 Bibliography: p.
 Includes index.
 1. Quilting—Polynesia. 2. Polynesians—Industries.
I. Title.
TT835.H335 1986 746.9'7'0996 86–6897
ISBN 0–8248–0975–0

For my parents,

Ruth B. and Reese W. Hammond

Contents

Color plates follow page 30.

Preface

Tīfaifai. The word is as Polynesian in flavor as the exotic sounding names of such places as Pago Pago and Bora Bora. To translate tīfaifai is to lose the meaning and the poetry of the word. The "loose" translation—Polynesian bedcover—is an inadequate description, while the literal translation—to patch repeatedly—is too narrow in meaning. To simplify matters, *tīfaifai* is a term which will be used to refer to all Polynesian applique and piecework fabrics from the islands of eastern Polynesia. For more information on the use of the term, see "A Note About Polynesian Words."

Returning to the United States in 1973 after a year in New Zealand where I had studied Maori arts and crafts, I stopped for a few days in Tahiti in the Society Islands. I visited the public market, many tourist shops, and even some Tahitian homes; nowhere did I see tīfaifai. I was not aware of their existence until some time later when I came across a short article on the subject of Tahitian tīfaifai written by Father Patrick O'Reilly. The tīfaifai that O'Reilly described from the 1950s sounded much like the historical and contemporary Hawaiian quilts with which I was familiar. I wondered if Tahitian women were still creating them and whether there were other regional styles of piecework and applique fabrics in Polynesia.

I reasoned that a good starting point to investigate my questions might be through correspondence with the clergy of Tahiti. Therefore, I wrote to several ministers who responded that the art form was flourishing among women in their congregations. A few people sent names of women known to be experts at making tīfaifai, and others made references to other regional styles such as the *tīvaevae* of the Cook Islands.

The more I learned about tīfaifai through correspondence, the more questions I had. I was puzzled over the fact that I had not seen any during my visit to Tahiti; but with the help of responses to some questionnaires I sent to Tahitian women knowledgeable about tīfaifai, I was able to piece together possible reasons.

I eventually learned that a tradition of making tīfaifai or quilt-like items comparable to those I was to find in eastern Polynesia does not exist in western Polynesia. Although women in the Samoan, Tongan, and Fijian Islands have adopted Western fabric, they continue to make and use bark cloth (sometimes called tapa), the indigenous fabric that was made throughout Polynesia prior to Western contact.

In September 1977, I traveled to Tahiti to begin my study of eastern Polynesian tīfaifai and quilts. In order to study tīfaifai as a unified, but regionally diverse, art form, I chose to concentrate my year's research in four large island groups of eastern Polynesia: the Society Islands, the Austral Islands, the Cook Islands, and the Hawaiian Islands. In addition, I collected some historical data on tīfaifai from the Tuamotu Islands.

I began my study on the islands of Tahiti, Ra'iatea, Taha'a, and Maupiti in the Society Islands. Although I visited Tubua'i (Tupua'i) and Ra'ivavae in the Austral Islands, I focused my research on Rurutu as the locally acknowledged "center" of the tīfaifai tradition in that island group. From French Polynesia I traveled to Rarotonga in the Cook Islands and later to O'ahu in the Hawaiian Islands.

On all the islands with the exception of O'ahu, I was able to live with Polynesian families. This arrangement made it possible for me not only to observe women creating tīfaifai and people using tīfaifai in their homes in an intimate and complete way but also to gain access to a great deal of information on the Polynesian cultures necessary to appreciate fully the varied roles of tīfaifai.

Tīfaifai have played significant social, economic, and ritual roles in eastern Polynesia for over a century. Yet, aside from a book on Hawaiian quilts by Jones (1973 [1930]) and Akana (1981), a handful of articles on Hawaiian quilting—for example, Barrère (1965), Plews (1973 [1933]), and Stevens (1971)—and the article on Society Islands tīfaifai by O'Reilly (1959), there has been very little written about this widespread and very important eastern Polynesian art form.

I hope that my contribution to the subject will give Polynesians and non-Polynesians alike a better under-

standing of the historical development of tīfaifai, an appreciation of the similarities and differences among regional styles, and an awareness of the ways in which Polynesians express themselves through tīfaifai.

The Polynesians are justly proud of their unique art. This pride was evident to me in their generosity in imparting information, answering my questions, and allowing me to photograph their work. Since this book could never have been written without the cooperation of the Polynesian people who helped me, I ask that any reader who finds creative inspiration from the book's photographs respect the Polynesians' ethical code which stipulates that no tīfaifai should ever be exactly duplicated in creation.

Acknowledgments

Without the assistance of many, this book would never have realized its final form. In acknowledging my debt to all those who aided me in my research and writing, I hope that I may convey the gratitude I feel for their individual contributions.

A number of scholars offered insights, advice, and assistance in different stages of this work: Dr. Harold M. Ross, Dr. Bengt Danielsson, Dr. Adrienne L. Kaeppler, Dr. Roger G. Rose, Aurora Natua, Father Patrick O'Reilly, Dr. Rebecca A. Stevenson, and Dr. Norman E. Whitten, Jr. Special thanks are extended to Dr. Claire R. Farrer who served as my graduate adviser. She generously offered encouragement and suggestions during the preparation of the dissertation from which this book originated. I am deeply grateful to Dr. Jack H. Ward and Dr. Linda Amy Kimball for lending their knowledge of Polynesian words and usage. I would also like to thank Mary Jane Knight of the Hawaiian Mission Children's Society for her library research.

In a book which features a visual art form, the importance of artists' drawings cannot be overstated. To Zbigniew T. Jastrzebski, senior scientific illustrator of the Field Museum of Natural History, and Joy Dabney, graphic artist of Western Washington University, I owe much. Their work greatly complements my written descriptions.

The generous assistance of individuals and organizations who lent photographs is deeply appreciated. Without their help this book would be incomplete. I wish to thank Margot Johnson, F. Edward Butterworth, Father Patrick O'Reilly, Claude Claverie, Rohea Tangaroa, Jeannette Ganivet, Elizabeth A. Akana, Rosalie Lailana Kekona and her son, Tommy Dean Kekona, and Deborah (Kepola) U. Kakalia. I am also indebted to Daughters of Hawaii; Honolulu Academy of Arts; Bernice Pauahi Bishop Museum; State of Hawaii Department of Accounting and General Services; Tahiti Tourist Promotion Board; National Museum of Ethnology, Leiden, the Netherlands; Field Museum of Natural History, Chicago, Illi-

nois; and E. P. Dutton, Inc., for the use of photographs. Thanks are also extended to Hal Cannon, Dave Kuntz, and David Minor for photographic work.

The Department of Anthropology at the University of Illinois, the Bureau for Faculty Research at Western Washington University, and The Western Foundation, Inc. aided in defraying research, publishing, and writing costs. I am grateful to Gail Fox of Western Washington University for typing the final manuscript.

A number of people have contributed very special efforts to this book. Gilbert and Lucette Tinembart, who resided in Tahiti during the time of my fieldwork, took me under their roof on several occasions and offered endless help and advice. I am also grateful to friends for their support: Mary Corlin, Debra Lee Doyle, Jan Smith, Elizabeth Streightif, and James Cutler. Special thanks are extended to Susan Gribbin for her drawings and assistance in assembling the final manuscript. My sister, Dr. Jeannine L. Hammond, and my parents, Ruth B. and Reese W. Hammond, provided encouragement as well as financial and emotional support throughout all stages of my work. To my mother, who read many versions of the manuscript with constant patience and untiring attention to detail, I wish to express my most heartfelt appreciation.

Finally, to the Polynesian people of the Hawaiian, Society, Cook, and Austral Islands, I owe my largest debt of gratitude. Without their kind assistance and support, this book would not have been possible. I would especially like to thank all those families who generously extended their hospitality to me.

It would be difficult to include the names of all who aided in my research. The names of many of those to whom I am grateful will be found throughout this book. Among those whose assistance was integral to my work were the members of the Tamara Pupu of Moerai, Rurutu; the Mangaitikai Roa Women's Group of Avarua, Rarotonga; and women of the L.M.S. Christian Church in Arorangi, Rarotonga. I also wish to thank Stella Ebb, Levy Hahe, Marie Taurua, Temana Vahine, Deborah (Kepola) U. Kakalia, and Elizabeth A. Akana.

A Note About Polynesian Words

There are many Polynesian words in this book. This note is included in order that the reader may better understand my use of the word tīfaifai and the linguistic rules which are applied to the Tahitian, Rarotongan, and Hawaiian languages.

The applique and piecework fabrics of eastern Polynesia are regionally differentiated by name (see map on next page). For purposes of simplification, the Tahitian word *tīfaifai* will be used in this book to refer to all regional forms, except when reference is made specifically to Hawaiian quilts. I have chosen the term *tīfaifai*, which occurs as both a singular and plural noun according to context, because it is recognized and used throughout much of eastern Polynesia. I retain the term quilt when referring only to the Hawaiian fabrics because the Hawaiians are unfamiliar with the word *tīfaifai*, and because Hawaiian quilts differ substantially in construction from other regional applique and piecework styles.

The languages spoken in the Hawaiian, Cook, Society, and Austral Islands are Polynesian languages and form part of the Malayo-Polynesian linguistic family. These languages commonly referred to as Hawaiian, Rarotongan or Maori (Cook Islands), and Tahitian (Society Islands and Austral Islands) show many similarities, owing to their common origin, yet they differ in some respects. For example, cognates may vary in meaning. Although the Hawaiian *aloha* corresponds to Tahitian *arofa* (and Rarotongan *aro'a*), it is often translated as love, kindness, or greetings, whereas Tahitian *arofa* is most often used to mean pity, sympathy, and compassion.

The Polynesian languages are based largely on vowels and vowel combinations, with a minimal use of consonants. All vowels and consonants are carefully sounded. Vowels may be short or long; vowel length often serves to distinguish meaning in words which are otherwise identical. Following standard linguistic conventions, a macron is used throughout this book to indicate a long vowel; unmarked vowels are short. Single vowels are not diphthongized and are sounded as follows:

Unstressed	Stressed
a like *a* in above	**a, ā** like *a* in far
e like *e* in bet	**e** like *e* in bet
	ē like *ay* in play
i like *y* in city	**i, ī** like *ee* in see
o like *o* in sole	**o, ō** like *o* in sole
u like *oo* in moon	**u, ū** like *oo* in moon

Vowels marked with macrons are held longer than those without.

Diphthongs are composed of two vowels (such as *ai* in *tīfaifai* or *ae* in *tīvaevae*). Each vowel is pronounced but the voice glides gently from one to the other with no noticeable break.

Consonants differ for the three languages. Tahitian has

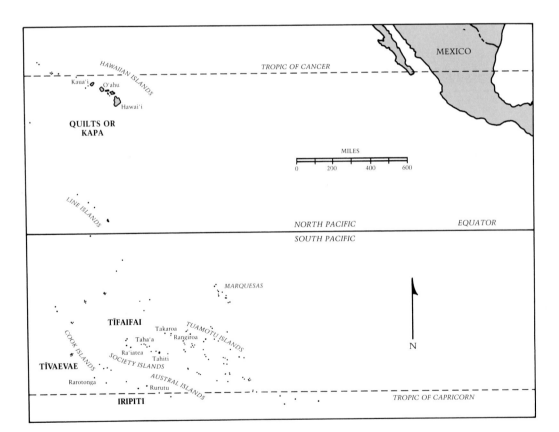

Map of eastern Polynesia with regional names of tīfaifai and quilts in the different island groups.

sounds approximated by *f, h, m, n, p, r, t,* and *v;* Hawaiian
has *p, k, h, l, m, n,* and *w;* while Rarotongan has *k, r, m,
n, ng, t, p,* and *v.* With some exceptions, these conso-
nants are pronounced approximately the same as in
American English. In some cases, Polynesian spellings
may be based on foreign spellings, as in the Tahitian *Iesu
Mesia* (Jesus Messiah). While the *s* is used in spelling, it is
pronounced as a *t.*

The glottal stop, represented by a single opening quota-
tion mark ('), is a consonant common to Hawaiian, Raro-
tongan, and Tahitian. It is pronounced in a fashion similar
to the sound between the *oh's* in English "oh-oh."

The accent usually falls on the next-to-the-last syllable
of a word, although some Polynesian words have no
accent. Stress is always placed on vowels marked with a
macron.

I have relied on Stephen Savage's *Dictionary of the
Maori Language of Rarotonga,* Mary Kawena Pukui and
Samuel H. Elbert's *Hawaiian-English Dictionary,* and
Yves Lemaitre's *Lexique du Tahitien Contemporain* for
spellings of Polynesian words. In a few instances, how-
ever, informants used words not listed in these sources;
in such cases I have written the words as spoken, but in
accord with the orthography of the language used. Any
mistakes are entirely my own.

1 *Contemporary Regional Styles*

The mosaic-like patterns of the *iripiti* of Rurutu, the beautifully executed embroidery of Cook Islands *tīvae-vae*, the undulating waves of quilting in Hawaiian quilts, and the simple elegance of color combinations in Society Islands *tīfaifai* are only some examples of the rich and varied spectrum of contemporary tīfaifai artistry. In addition to having different names, the Polynesian tīfaifai styles vary from region to region in method of construction and in design and motif (that is, a type of design which embodies a subject, theme, or idea). Yet, despite their differences, the tīfaifai of Polynesia have much in common. By using the general term *tīfaifai* throughout most of this book, I wish to draw attention to the many characteristics shared by the distinctive piecework and applique traditions of each region. In this chapter, however, I have retained the regional names since I focus specifically on differences in contemporary tīfaifai styles.

There are two basic styles of Polynesian tīfaifai— applique and piecework. Applique tīfaifai have designs cut from one or more pieces of fabric and sewn to a background fabric. The designs of piecework tīfaifai are created by sewing together many pieces of fabric; for these tīfaifai a separate layer of fabric serves to back the design layer and hide the raw edges of the seams. As Table 1 indicates, both piecework and applique tīfaifai are found throughout the island groups, but in each of the different areas, with a single exception, one style is more popular than the other. Only in the Cook Islands are the two styles equally popular at the present time.

Society Islands Tīfaifai

Tīfaifai Pū

Some women in Tahiti and the other islands of the Society group occasionally create piecework tīfaifai, known as *tīfaifai pū* (Plate 11). However, the piecework style is not nearly so popular here as it once was, and many of the

Table 1. Contemporary Regional Styles of Polynesian Tīfaifai and Quilts

Region	Style	
	Applique	Piecework
Society Islands	**Tīfaifai Pā'oti** or **Tīfaifai Tāpiri**: design created from one piece of fabric (with some exceptions), folded and cut in fourths, machine- or hand-sewn to background fabric.	*Tīfaifai pū:* created from small, geometrically shaped pieces of cloth sewn together by machine or by hand. Design layer is backed by a large piece of fabric.
Cook Islands	**Tīvaevae Manu**: "true" *tīvaevae manu* created like Society Islands applique style. Less common than **Tīvaevae Karakara** or **Tīvaevae Tātaura**—design created from individual pieces of fabric, elaborately hand embroidered to background fabric.	**Tīvaevae Tāorei**: generic name for all tīvaevae made with geometrically shaped pieces of fabric. Specifically refers to those made with square shapes. Variations include *tīvaevae uati* (diamond shapes) and *tīvaevae paka 'onu* (hexagonal shapes), hand- or machine-sewn. Design layer is backed by a large piece of fabric.
Rurutu in the Austral Islands	*Tīfaifai:* see Society Islands applique above. Most are imported from Society Islands.	*Iripiti* include **Iripiti Rima:** created from geometrically shaped pieces of fabric, usually squares, (also referred to as *iripiti pū*) sewn by hand; and **Iripiti Nira**: created from geometrically shaped pieces, generally rectangles and shapes other than squares, sewn by machine. Design layer is backed by a large piece of fabric.
Hawaiian Islands	**Hawaiian Quilts** include **Kapa Lau**: design created from one piece of fabric, folded and cut in eighths to form four or eight identical motifs; and **Kapa 'Āpana**: design created from separate pieces of fabric and consists of a central medallion (a *piko*) and a border (*lei*). In both styles, designs are hand-sewn to a background fabric which forms part of the design layer. A middle batting layer and a backing layer are quilted to the top design layer with quilting stitches, usually in the contour quilting style.	*Kapa pohopoho:* made from geometrically shaped pieces, machine- or hand-sewn. Design layer is backed by a large piece of fabric. Rarely created.

NOTE: Names in bold face type indicate most popular and prevalent contemporary styles.

tīfaifai pū of Tahiti today are made by women who have immigrated from the Tuamotu Islands, which lie east of the Society Islands.

Women create the geometric designs of tīfaifai pū by sewing variously shaped pieces of solid-colored fabric together, first in sections called *pū* and then together as a whole. To complete a tīfaifai pū, a woman backs the design layer with a separate piece of fabric. She secures the back by folding the edges over the front sides of the tīfaifai and sewing them down. Cotton fabric, usually in vivid, solid colors, is used to make tīfaifai pū.

Although the designs of most tīfaifai pū have counterparts in Western quilts, islanders give their tīfaifai designs names that reflect Polynesian thought and association, for example, "Turtle," "Stars," and "Pandanus Fruit Garland."

Tīfaifai Pā'oti

The applique style tīfaifai, called *tīfaifai pā'oti* or *tīfaifai tāpiri* (Figure 1), is the most popular type of tīfaifai in the Society Islands today. Tīfaifai pā'oti are made with two layers of fabric. Instead of using the older technique of sewing fabric strips together to make the background fabric, many women now purchase bed sheets. They also buy sheets for the foreground fabric from which they cut the tīfaifai pā'oti design. Permanent-press sheets are especially valued for their practicality.

To create a tīfaifai pā'oti, a woman folds into fourths the square of fabric chosen for the top layer. She may trace or draw a pattern directly onto the material. (Some women are able to envision a design without the aid of this step.) She then cuts the design from the folded fabric, taking care that some of the pattern touches the two folded edges so that, when unfolded, the entire top will have four identical, unseparated designs. Occasionally, a woman cuts a separate border or, more rarely, makes separate designs from different pieces of fabric. The foreground design is basted onto the background fabric, the raw edges are folded under, and the design sewn down, usually by hand, with overhand stitches. A sewing

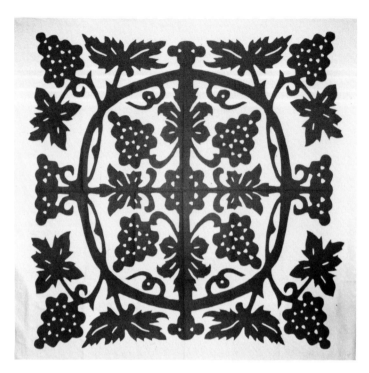

Fig. 1. "Grapes" (Vine). Applique, tīfaifai pāʻoti. Tahaʻa, Society Islands. ca. 1969. Green on white. 99″ × 83″. Hand-sewn. Made by Apine Ruahe and owned by her sister, Aiurahi Sang Wong-Sang.

machine with a zigzag attachment can be used to stitch down the design; there is then no need to turn under the edges of the fabric. Most women of the Society Islands still believe that hand sewing is the most durable and desirable construction technique, but today many of them machine sew applique tīfaifai to save time.

Traditional tīfaifai pāʻoti color combinations were red on white or white on green. These color combinations remain popular today, but numerous other color combinations are used as well—sometimes different shades of the same color, or strongly contrasting color combinations, such as orange and white or purple and yellow. In general, the only rule governing color selections is that the tīfaifai maker should avoid violating natural colors of motifs. Thus, most women consider red for "Breadfruit" (ʻUru) and blue for "Tahitian Flower" (Tiare Tahiti) inappropriate since breadfruit is green (Plate 3) and the Tahitian flower is white.

Most tīfaifai pāʻoti designs are positive; that is, the shapes in the upper layer of fabric form the design. Some

designs, however, are inversed: a negative or cut-out space in the top layer of fabric allows design shapes to show through from the background fabric. The tīfaifai in Figure 2 is an example of an inversed design. There are no special names to distinguish these two types of design.

Very recent innovations in tīfaifai pā'oti include the use of fabric ordinarily used for *pāreu*, the Tahitian wrap-around garment which both men and women wear as informal dress. The imported cotton pāreu fabric, which usually has a tropical floral design in two highly contrasting colors, is sometimes used as the top layer of fabric from which the applique design is cut (Figure 3). Another recent innovation is to use more than one color of fabric for the tīfaifai designs (Plate 4), in which case patterns must be devised that consist of several pieces of fabric. The conventional four-part arrangement is still retained, however, and the overall design remains very similar to more traditional patterns.

Theoretically, a woman may use any design in creating her tīfaifai. In reality, however, most women draw on a number of popular and well-known motifs to create fabric representations of objects, plants, birds, and the like.

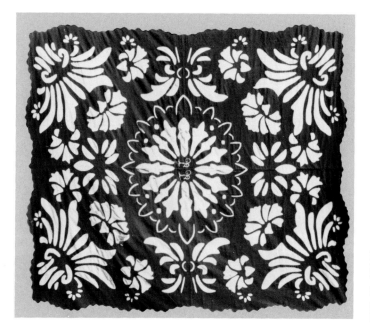

Fig. 2. "Pinks" (Oeillet). Reverse applique, tīfaifai pā'oti. Tahiti, Society Islands. ca. 1962. Red on white. 87″ × 85″. Hand-sewn. Made and owned by Tetua Jourdain.

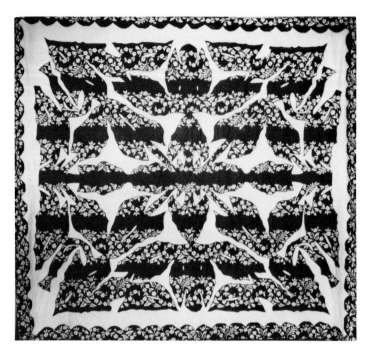

Fig. 3. " 'Ape Leaf" ('Ape). Applique, tīfaifai pāʻoti. Tahiti, Soċiety Islands. 1974. Green and white pāreu print on white. 93″ × 85″. Machine-sewn. Made and owned by Celine Manate.

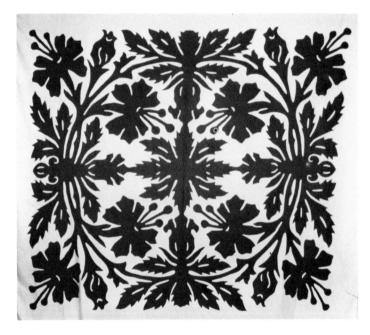

Fig. 4. "Hibiscus" ('Auti). Applique, tīfaifai pāʻoti. Tahaʻa, Society Islands. ca. 1940–1950. Red on white. 99″ × 85″. Hand-sewn. Created by Teroo Tufaea; owned by Teraimateata Tetauira. Hibiscus motifs are prevalent throughout the islands in both piecework and applique styles.

Flower motifs are the most popular and include many different kinds. Flowers are often selected for their beauty (Figure 4), but some, such as the "Tahitian Flower" (Tiare Tahiti), the national flower of Tahiti (Figure 16), and the "'Apetahi Flower" (Tiare 'Apetahi), found on Mt. Temehani on the island of Ra'iatea, also carry connotational meanings by virtue of their association with cherished land. Other applique motifs selected for tīfaifai pā'oti range from shells, leaves, coconut trees, and peacocks to clocks, chandeliers, butterflies (Plate 9), and mermaids. Most tīfaifai are assigned Tahitian names which describe the motif, but some French words are also occasionally used.

Cook Islands Tīvaevae

Tīvaevae Tāorei

Most people on the island of Rarotonga in the Cook Islands use *tīvaevae tāorei* as a general term for any piecework style tīfaifai. (Rarotongan styles and terms for tīvaevae appear to be the same on other islands of the Cook group.) Strictly speaking, however, the name specifically refers to piecework tīvaevae constructed from square pieces of cloth, as reflected in the word *orei* which means handkerchief. Some people refer to tīvaevae made with hexagonal pieces of fabric (Figure 5) as "Turtle Carapace" (Paka 'Onu) and use the term *uati* (from the English word *watch*) for tīvaevae with diamond shapes.

Women of the Cook Islands create tīvaevae tāorei from small pieces of cotton cloth which they sew together by hand or on a sewing machine. They join pū, the repeating sections of design in a tīvaevae tāorei, with *pongo*, or half-sections of the designs, to create the tīvaevae's overall pattern. The pū and pongo, which vary in number according to different designs, are often joined with an inner border called *aua* or *vae*, also made up of small, geometrically shaped pieces of cotton fabric (Figure 6). The four sides of the completed piecework top are then attached to a backing fabric, which is folded over the

Fig. 5. "Hibiscus" (Kaute). Piecework. The hexagonal shapes of fabric make this a "Turtle Carapace" tīvaevae tāorei. Rarotonga, Cook Islands. White, purple, red, yellow, blue, orange, turquoise, and light green on turquoise. Hand-sewn. Owned by Mme. Estall.

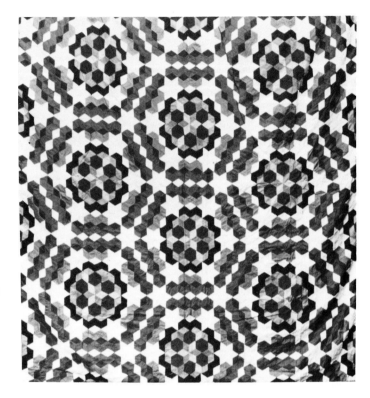

Fig. 6. "Lily" (Lili). Piecework, tīvaevae tāorei. Rarotonga, Cook Islands. ca. 1975. Hand-sewn by members of a Women's Federation group. Owned by the Rarotongan Hotel. In the Cook Islands, as well as other areas of eastern Polynesia, tīfaifai are becoming increasingly visible as symbols of Polynesian cultural heritage.

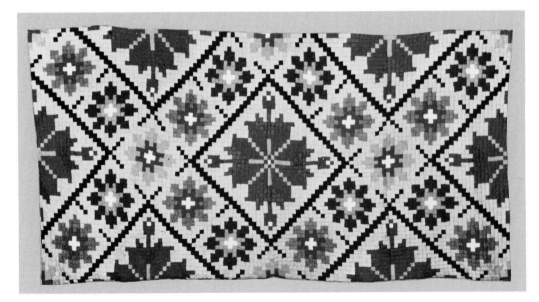

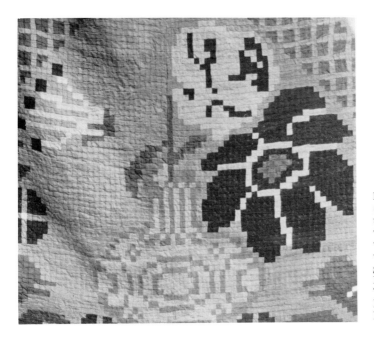

Fig. 7. Detail of tīvaevae tāorei (name unknown) from Raro-tonga, Cook Islands. Flowers, vase, and bird motifs are created with small squares of orange, white, purple, yellow, red, green, pink, and blue cloth. Hand-sewn. Made in 1960 by Teupoko Hosking and given to her daughter, Louisa Cowan, at her daughter's wedding.

edges of the top layer to conceal the raw edges, and sewn down.

By carefully selecting the colors and shapes of the indi-vidual cloth pieces which she sews together, a woman creates the overall design of a tīvaevae tāorei. Many tīvaevae tāorei embody motifs from nature and they are named accordingly. Flowers, vases, birds, butterflies, crowns, anchors, and other recognizable objects are portrayed in mosaic-like fashion by placing different-colored pieces of fabric beside one another (Figure 7). Usually, women who make tīvaevae tāorei with such motifs use square pieces of fabric. However, in a popular design called "Turtle Carapace Turtle" (Paka 'Onu 'Onu) with an overall pattern of turtles, arrangements of hex-agonal pieces of fabric replicate the design on a turtle's back (Figure 8).

Tīvaevae designs are sometimes made from pieces of fabric of one shape only; in other cases, from two or more different shapes. A designer may repeat motifs from nature in an overall pattern, or arrange clusters of shapes in larger geometrical or abstract designs of stars, hexa-gons, and diamonds.

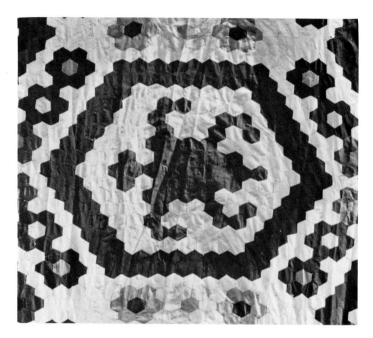

Fig. 8. Detail of "Turtle Carapace Turtle" (Paka 'Onu 'Onu). Piecework, tīvaevae paka 'onu. Rarotonga, Cook Islands. 1971. Brown, yellow, blue, red, white, green, orange, pink, and aquamarine. Hand-sewn by a group of eight women in a Women's Federation group. Owned by Tere Pearson. The turtle motif occurs on two levels—the hexagonal shapes of fabric are likened to the turtle carapace shapes and the turtle design is executed in pieces of brown fabric.

Though there may be no recognizable image in such abstract, geometrical designs, the women who make them almost invariably assign names to these tīvaevae to suggest an image or an idea. For example, there are many variations of a design created with squares of fabric in selected colors so placed as to form an overall pattern of adjoining diamonds. If, in the diamond motif, two pieces of material of the same color are placed beside one another, as two red pieces of fabric side by side, the design is called "To Marry" ('Akaipoipo). Other color arrangements of the same diamond design have different names. For example, a woman can create a "Hibiscus" (Kaute) motif with the same overall diamond design by selecting colors associated with the flowers and arranging them in appropriate patterns.

Color is an essential element in tīvaevae tāorei, the primary colors used giving them a vibrant, dramatic quality. The use of two colors alone is rare, and often four or more are combined to produce a rich, mosaic-like effect. Women usually depict motifs in colors natural to them, but artistic license allows occasionally for such

unconventional coloring as blue turtles. The use of primary, contrasting colors helps to give a highly two-dimensional character to designs for tīvaevae tāorei. Although they sometimes place colors together in such a way as to produce shading (for example, pinks beside reds), most Rarotongan women choose color combinations that lend "flatness" and frontality to the designs.

Tīvaevae Manu

Rarotongans use the term *tīvaevae manu* (Plates 7 and 12) to refer to any applique tīvaevae, a style that is as popular in Rarotonga as tīvaevae tāorei. The reason for the word *manu*, which may be translated as bird or kite, in referring to applique designs is not readily apparent. Perhaps, as some Rarotongans suggest, the term came into use because an early applique tīvaevae incorporated a bird motif. On the other hand, the term might refer to the possible analogy for a woman setting the applique motif of the foreground against the backing layer of fabric, just as a bird or kite is framed against a background of sky.

Rarotongan women sometimes create tīvaevae manu that are similar to Society Islands tīfaifai pā'oti. These tīvaevae, which may well have had their origin in the Society Islands, utilize less of the background fabric in the overall design than most Society Islands applique tīfaifai. Also, Rarotongan women sometimes applique the foreground motif to the background fabric with embroidery floss, and thus create a stitchery pattern around the outline of the motif.

The most popular style of tīvaevae manu in Rarotonga today is one with several separate designs appliqued onto a background cloth. However, some Rarotongans contend that these are not true tīvaevae manu because the foreground pattern is not fashioned from one piece of fabric. Tīvaevae that are made with several separate designs are usually called *tīvaevae karakara* or *tīvaevae tātaura*. The term *karakara* refers to the different colors of fabric in the separate pieces of cloth appliqued to the background fabric. The term *tātaura* is a reference to the use of embroidery cotton on the appliqued designs as a decorative

element. The two names are equally descriptive since many women incorporate both embroidery and several different colors of material into this style.

Women who make tīvaevae karakara draw the designs onto cotton fabric of different colors, cut them out, and sew them onto a contrasting background fabric which is made from three strips of cotton cloth sewn together. They elaborately embroider the design pieces before they applique them onto the background material with more embroidery stitches (Plate 5). They are able to achieve a great deal of artistic realism by embroidering leaf veins, flower pistils, and other details onto the cloth. Several different embroidery stitches, known in local terminology by names such as oyster, centipede, and saw stitch, are used in many colors of embroidery floss.

Often, the foreground patterns in a tīvaevae karakara leave very little background fabric showing; single motifs of tīvaevae karakara may measure three feet across. The tendency to fill so much of the background probably originated from women copying older tīvaevae manu patterns made from a single piece of fabric which had designs that filled the background space almost entirely.

Theoretically, any subject is appropriate as a motif for a tīvaevae karakara. However, most people prefer flowers. A woman may create a tīvaevae with one type of flower only, or she may use a variety. Likewise, some women make flower patterns in two colors—one color for the blossoms and another for the leaves—while others incorporate a number of colors in their designs.

Rurutuan Iripiti

Iripiti Rima

Most women on the island of Rurutu in the Austral Islands use the term *iripiti* when referring to any type of piecework (Figure 9), and *iripiti pū* when referring specifically to iripiti they make from hundreds of small, solid-colored, square pieces of cotton fabric. Although people of Rurutu import or sometimes make Society Islands applique-style tīfaifai (which they usually refer to as

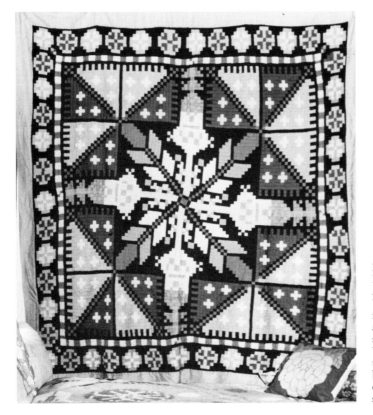

Fig. 9. "Ordinary" (Ordinaire). Piecework, iripiti rima. Rurutu, Austral Islands. ca. 1977. Yellow, orange, white, pink, red, green, maroon, light blue, and dark blue on orange. Hand-sewn. Designed by Temana Vahine; executed by women of the group Tamara Pupu; owned by Taniera Vahine. The design is created from hundreds of small squares of fabric.

tīfaifai), the applique style is much less popular and common than the piecework style.

Rurutuan women regard hand-sewn iripiti, known as *iripiti rima*, as the most beautiful, durable, and valuable style. A woman who makes an iripiti rima rarely incorporates fewer than five colors in her composition, and she arranges the colors to create maximum contrast and visual impact. Iripiti rima designs resemble mosaics, and the color contrasts sometimes make a pattern appear three-dimensional.

Iripiti rima usually embody motifs from nature, such as butterflies, flowers, and fruit. Stars and lamps are other popular subjects. Almost always, a woman repeats an iripiti motif several times in a symmetrical arrangement. She often joins several identical sections (pū) together, separated by contrasting, border-like designs called aua, to complete the overall design.

A widespread and recent innovation, which appears to be less than one generation old, is the practice of some women to "write in" a person's name on an iripiti pū, using some of the fabric squares to form block letters. The name is that of the person (often a close family member) for whom the iripiti is intended (Figure 10).

Today there are a number of iripiti patterns that differ markedly from the majority of conventional Rurutuan designs. These may have one overall motif, or a single motif and its mirror image may be placed face-to-face (Plate 6). These patterns were devised by an innovative and expert creator of iripiti who has adapted ideas from Western needlecraft books to the traditional iripiti techniques.

Iripiti Nira

Women in Rurutu also make machine-sewn iripiti. These *iripiti nira* are generally made from large pieces of fabric cut in different geometrical shapes. Such geometric and

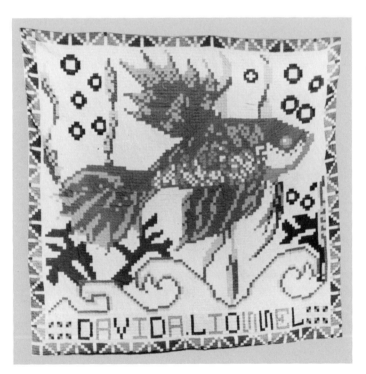

Fig. 10. "Panapana Fish" (I'a Panapana). Piecework, iripiti rima. Rurutu, Austral Islands. ca. 1970. Orange, white, red, maroon, light blue, dark blue, light green, and dark green on blue. Designed by Temana Vahine. Hand-sewn by her and other members of the group Tamara Pupu for the mother of David A. Lionel. The work, which bears his name, will be presented to him at his marriage.

abstract iripiti designs are often assigned names that are meaningful in the Rurutuan realm of experience. One such popular design is "Fence" (Patu; see Figure 45).

In creating a machine-made iripiti, a woman usually selects two or more colors that are highly contrasting. The backing fabric may be another bright color or white. Because of the relatively large size of the fabric pieces used it is possible to sew them together easily on a sewing machine. Although iripiti of this type are less valuable in the eyes of the Rurutuan people than the hand-sewn style, many women prefer iripiti made by machine as a more practical choice in terms of money and time.

Hawaiian Quilts

Kapa Lau and Kapa ʻĀpana

Unlike the tīfaifai of the Society, Cook, and Austral Islands, Hawaiian quilts are composed of three layers: a top design layer, a middle batting layer, and a bottom backing layer. Early in the history of Hawaiian quilt making, the applique style became much more popular than the piecework style, called *kapa pohopoho*. There-fore, with some exceptions, the only contemporary style of Hawaiian quilt is applique.

Many people distinguish between two types of Hawai-ian applique quilts. *Kapa lau* are quilts with a central design of four or eight identical segments *(ku)* cut from a single piece of fabric (Figure 11). The design may be cut in such a manner that a border design is included as part of the overall pattern (Plate 13), or a separate border may be cut. Unlike early Hawaiian kapa lau designs, which were often fairly simple with large areas of background visible, the foreground designs in many contemporary Hawaiian kapa lau are complex and fill the background.

The designs for *kapa ʻāpana* are created from separate pieces of material. Many have a central medallion *(piko)* and an inset border which is often thought of as a lei. The border may incorporate design elements that echo the central pattern. Other kapa ʻāpana feature four or more separate motifs symmetrically arranged around the

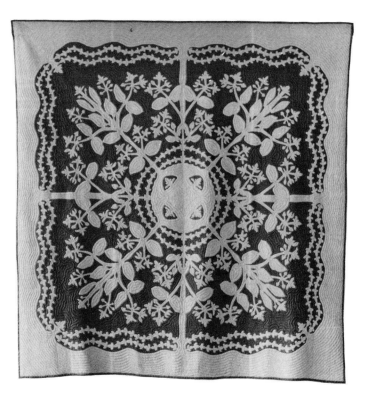

Fig. 11. "Crown of Queen Liliuokalani" (Kalaunu O Liliuokalani). Applique, Hawaiian quilt. O'ahu, Hawaiian Islands. Lavender on purple. Hand-sewn. Made by Josephine Hanakahi on commission from the State Foundation on Culture and the Arts. The quilt hangs in the hallway of the Liliuokalani Building in Honolulu. The artist selected the design and colors because the purple crown flower was a favorite of Queen Liliuokalani (1838–1917), last reigning monarch of the Hawaiian Islands.

quilt's center. Sometimes the motifs are linked with fabric designs (Figure 12).

Some Hawaiian quilt designs combine piecework and applique elements. However, in design arrangement they are similar to kapa 'āpana (Figure 47).

A woman creates a medallion or overall applique design for a Hawaiian quilt by folding a square of fabric into eighths. She may trace or draw a design onto the folded fabric or she may cut out the design freehand. While the manner of folding a Hawaiian applique design differs from that of Society Islands and Cook Islands applique designs (Figure 13), the manner of cutting is the same. If she wishes to add a separate border, it is cut from another piece of fabric folded into fourths or eighths. She bastes and then sews the applique design to a contrasting piece of background fabric, usually with an overcast stitch. To complete the Hawaiian applique quilt, she joins the design layer to a middle batting layer of cotton or synthetic batting and a fabric backing. She does this by

taking small quilting stitches through all three layers of
material. The quilting stitches, which form visible lines
of design, are decorative as well as functional. Many
women still use a frame to hold the quilt and sew from
the center outward to the edges. Other women quilt by
working on one small section at a time, using a large
embroidery hoop balanced on the lap (Figure 14) or sup-
ported on a table.

Contour quilting, called *humu lau* (also *kuiki lau* and
echo quilting), is the characteristic quilting technique
used for Hawaiian applique quilts (Figure 15). Following
the outline of the applique design, women quilt over the
entire surface, usually keeping the rows of stitching half
an inch apart. From the center of the quilt *(piko)* out to
the borders *(ho'opae)*, the quilting lines echo the lines of
the applique pattern and create a design element separate
from the applique pattern and the color combinations.
Hawaiian quilters often compare contour quilting to
breaking waves. When skillfully sewn, the "peaks" of the
waves are supposed to be lined up together, radiating out-

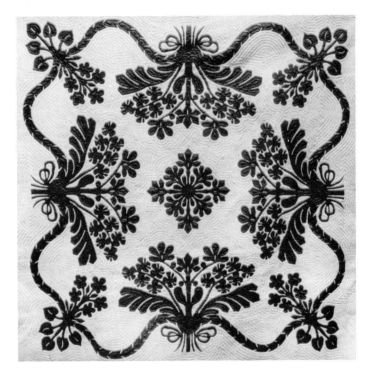

Fig. 12. "Gentle Hawaiian
Breeze." Applique, Hawaiian
quilt. O'ahu, Hawaiian Islands.
1982. Dark red on white. 90" ×
90". Hand-sewn. Designed by
Elizabeth A. Akana; sewn by
Kathy Dallas. This quilt is
named for "a love carrying
breeze that carries love to the
world."

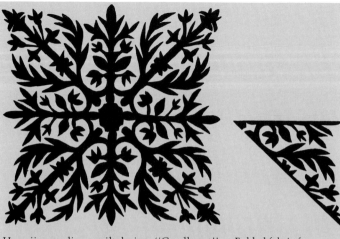

Hawaiian applique quilt design, ''Candlenut'' (Kukui) is quadriaxially symmetrical as a result of folding the foreground fabric into eighths.

Folded fabric for Hawaiian applique quilt.

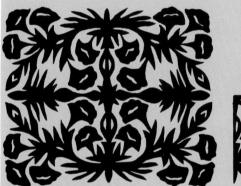

Society Islands applique tīfaifai design, ''Yellow Flowering Vine'' (Liane Jaune) is biaxially symmetrical as a result of folding the foreground fabric into fourths.

Folded fabric for Society Islands applique tīfaifai.

Fig. 13. Comparison of Hawaiian applique quilts and Society Islands applique tīfaifai.

ward. In fact, Hawaiian quilters, when referring to the border, maintain the ocean metaphor in the term *ho'opae*, which means ''to go ashore.''

Contemporary Hawaiian quilts are made in a variety of colors and color arrangements. In addition to historical color combinations, which included two or more colors as well as the use of print fabrics, contemporary quilters may use two shades of the same color.

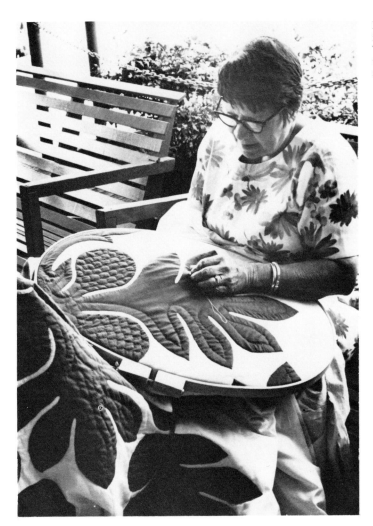

Fig. 14. Hawaiian quilter working with an embroidery hoop. This photograph shows some of the designs created with quilting stitches.

While early Hawaiian quilters may have been limited in choice of colors to whatever fabric was available, and may have been interested primarily in visual effect, contemporary quilters often select colors on the basis of realism or symbolic connotations. Motifs from flowers or plants are often fashioned as nearly as possible in their natural colors. Red and yellow are usually used for motifs associated with Hawaiian royalty because those were the colors that signified Hawaiian chiefly rank. The feather cloaks, capes, and helmets worn only by Hawaiian chiefs were made from red and yellow feathers from four or five

Fig. 15. Detail of " 'Ilima Lei" (Lei 'Ilima). Applique, Hawaiian quilt. O'ahu, Hawaiian Islands. 1964. Yellow and dark green on light green. Hand-sewn. Made by Deborah (Kepola) U. Kakalia for her granddaughter. Quilting stitches follow the contour of the motifs.

species of indigenous Hawaiian birds. Some quilters select colors with the sex of the quilt's recipient in mind, since some colors are considered feminine (lavender, for example) while others are considered masculine (brown).

The five categories of popular Hawaiian quilt designs proposed by Stella Jones in 1930—natural phenomena, historical events, biblical themes, aesthetic objects, and abstract ideas and emotions—are still popular today. Occasionally, motifs from more than one category are combined in a design.

Symbolism is often an important aspect of Hawaiian quilt designs, and there is a generally understood meaning attached to many motifs. For example, according to one Hawaiian quilter, "Breadfruit" (Ka 'Ulu) is associated with any kind of growth and would therefore be an appropriate motif for the design of a quilt presented to a businessman (Figure 68). The association of personal symbolism with motifs is more prevalent in Hawaiian quilts than in other tīfaifai traditions. Hawaiian women often personalize individual quilt designs, giving them poetic names that refer to specific events or feelings.

Artistic Principles

Despite the diversity in regional tīfaifai styles, women throughout eastern Polynesia apply a common set of artistic principles in creating tīfaifai. Technical skill, symmetry, contrast, repetitions with variations, and framing are the five most important artistic principles involved in designing, as well as in judging, a tīfaifai.

The skillful use of technique is essential in creating tīfaifai. Women often speak of the importance of careful, meticulous work in creating a fine tīfaifai. They also emphasize the ability to visualize the design of either a piecework or an applique tīfaifai as a necessary component of technical skill.

Although a woman may assert that any motif or design may be used in a tīfaifai, actual practice proves that most women rely a great deal on convention and consider some patterns aesthetically acceptable and others unacceptable. For example, throughout eastern Polynesia, flowers

are considered appropriate motifs, whereas animals generally are not. With regard to Hawaiian quilts, Plews (1973:7) states, "Animals, birds or people are considered unlucky or perhaps too restless to put on bed covering by some people, so they are seldom found." However, there are exceptions. In the Society Islands, women sometimes create tīfaifai with bird and mermaid motifs.

Within the conventions established by practice, women who invent new applique patterns say they rely on their own imaginations for inspiration. Their observations of the world around them—flowers, leaves, trees, and other objects—provide the basic material for their ideas. Jones (1973:5) relates the story of a young Hawaiian woman who "dreamed" a quilt pattern (see pages 101–102), but none of the women I talked to told me that they were inspired through dreams.

Most women use a paper pattern in cutting an applique design from cloth. Many women feel unable to draw the design onto the paper, and some consider the actual process of cutting the design from folded fabric very difficult. Thus the ability to draw and cut applique designs is admired and greatly respected among Polynesians.

Careful planning is required in designing a piecework tīfaifai. Whether a woman relies on designs from a Western needlework book or from an older tīfaifai, or whether she creates an original design, she must be able to visualize the finished product in order to cut the number of pieces of fabric needed and to place them in such a way as to achieve the effect she desires. People on the island of Rurutu recognized one woman as the *rangatira* or "chief" of tīfaifai makers there because of her ability to organize hundreds of small squares of fabric into a design of great complexity.

The process of sewing a tīfaifai is a fundamental part of its technical execution. Although some piecework tīfaifai are sewn on machines, especially those which incorporate strips of fabric, many women still sew piecework by hand. They often express a definite preference for hand-sewn tīfaifai, which they believe are more durable and therefore of better quality. Careful hand sewing in applique tīfaifai is especially admired. Although machine-sewn applique tīfaifai are gaining popularity in the

Society Islands, those sewn by hand are still the most highly valued, as is reflected in the difference in price between machine-sewn and hand-sewn work. Hand stitching is very definitely an important element in the creation of Cook Islands applique tīvaevae; in these, embroidery is used to embellish the design. Hand sewing is also important in Hawaiian quilts because the quilting stitches form part of the overall design. Uniformity of stitches is a necessary attribute of truly fine tīfaifai, whether of piecework or applique style; and for this reason, many women choose to stitch their own tīfaifai alone rather than to work in a group.

Symmetry is a fundamental artistic principle. Although the importance of this design criterion is not often discussed, one woman in Rarotonga pointed out the desirability of making a symmetrical design which would hang down around the four sides of a bed.

Applique designs created from one piece of fabric are symmetrical because of the manner in which the fabric is folded and cut. Applique designs which have separate design elements are symmetrical because the different parts of the design are arranged around a central point.

Piecework tīfaifai designs are also symmetrical, usually in three different ways. The individual fabric pieces are cut in symmetrical shapes—squares, triangles, parallelograms, and rectangles. Individual sections (pū) of the tīfaifai are often arranged symmetrically, and women almost invariably repeat nongeometrical motifs, such as birds or flowers, in other sections of the tīfaifai to achieve overall symmetry. Thus the tīfaifai as a whole, composed of several identical sections geometrically aligned, is also symmetrical. Along with symmetry in shape and arrangement of the fabric pieces, women often use color in piecework tīfaifai to achieve another form of symmetry. For example, a red square in the upper left-hand corner of a tīfaifai section may mirror another in the upper right-hand corner of the same section.

Contrast is another important artistic principle in tīfaifai design. It is achieved through both construction and use of color.

In the construction of an applique tīfaifai, the foreground fabric, from which the design is cut, contrasts

with the background fabric in color as well as in form.
This principle holds true both in positive and negative
applique designs.

In piecework tīfaifai, different shapes of fabric, often of
contrasting colors, are placed in various arrangements.
Although in actual construction, piecework tīfaifai do not
exhibit a foreground and a background, a similar effect is
achieved through the creator's use of colors.

Polynesian women do not have a special vocabulary for
describing the effects of color contrast, but they clearly
recognize its impact. An emphasis on color contrast
accounts, in large measure, for the combination of several
primary colors so typical of Cook Islands applique and
piecework tīfaifai and of other regional piecework styles.

Women choose colors carefully to achieve contrast.
While they sometimes take symbolism into consider-
ation and usually select particular colors in order to
approximate realism in plant motifs, they always con-
sider the contrasting properties of the color combinations
they use. Society Islands women sometimes criticize a
tīfaifai on the basis of whether or not the positive design
"stands out" from the background color. If the contrast is
sharp, such as red against white or white against green,
women consider that tīfaifai more beautiful than one in
which the contrast between design and background is
not very distinct. Different shades of the same color are
beginning to come into vogue in the Society Islands and
the Hawaiian Islands, but the women still emphasize
contrast, and a tīfaifai maker often uses the darker shade
for the upper, design layer in order to provide optimum
contrast with the background fabric.

An emphasis on contrast accentuates the two-dimen-
sional quality of designs of both applique and piecework
tīfaifai. Although some tīfaifai give the illusion of depth
from the use of shade differences in color, such tīfaifai are
rare. Flat, outlined designs are the rule. Contrasting col-
ors may serve to outline a design, as do also the lines of
hand stitches which are visible as part of the design in
Cook Islands tīvaevae and Hawaiian quilts.

Another artistic principle evident in tīfaifai design is
repetition with variation. There are many popular appli-
que and piecework designs for tīfaifai, but variations on

Fig. 16. Four "Tahitian Flower" (Tiare Tahiti) tīfaifai from the Society Islands. Applique, tīfaifai pāʻoti. All hand-sewn and white on green.

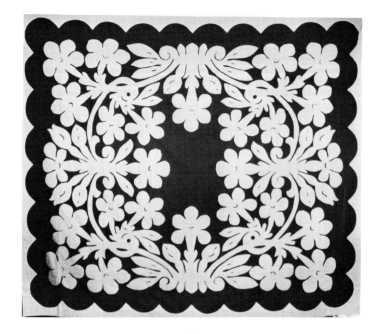

a: 1970. Tahaʻa. Created by Helene Mahio.

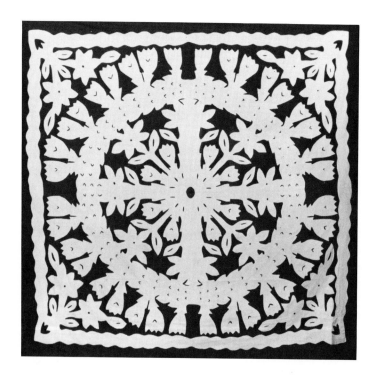

b: 1962. Maupiti. A woman named Terai designed, cut, and basted the tīfaifai design; Tevahinefaimanovaiotaha Raioho, the owner, sewed the tīfaifai.

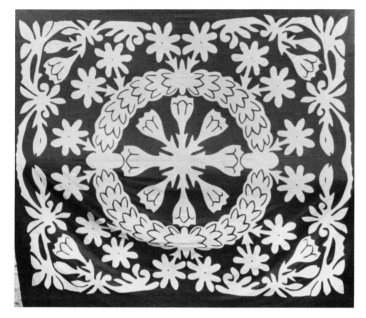

c: 1965. Taha'a. Created and owned by Amelia Manual.

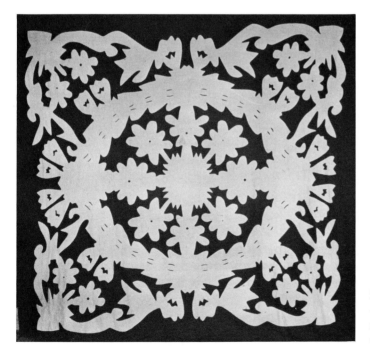

d: ca. 1950. Taha'a. Created by Teroo Tufaea; owned by Teraimateata Tetauira who received it as a present from her aunt.

these themes are highly valued. In applique designs, variation is achieved more often in the design's form than in the colors used; in piecework designs, variation comes generally from choice of colors.

Approximately fifteen tīfaifai designs are extremely popular in the Society Islands. One of these, perhaps the most popular of all, is the "Tahitian Flower" (Tiare Tahiti). Almost invariably, a woman creates the design in white on green to imitate the natural color of the flower. While the color combination of the tīfaifai rarely varies, there are endless individual interpretations of the flower motif (Figure 16). There are similar variations for all popular applique designs throughout eastern Polynesia.

Women modify and individualize designs in piecework tīfaifai by varying the colors used. The same piecework design may appear entirely different in two tīfaifai if the color schemes are different. If a woman makes a second tīfaifai with one design, she usually changes the colors because she thinks that it would be boring to create two tīfaifai exactly the same. The same would be true if a woman were to make two tīfaifai of the same applique pattern. Thus a woman can use the same design again and again, using different color combinations, to create many different tīfaifai—sometimes, in this way, individualizing tīfaifai for specific purposes.

In addition to emphasizing variation between two or more complete tīfaifai, women often employ the artistic principle of repetition with variations within a tīfaifai design. For example, in the "Tahitian Flower" design, women sometimes create variations of the flower by representing different stages of the flower's development. They also vary the same motif in some piecework and applique tīfaifai by using different colors. A woman who creates a "Hibiscus" design with repeating motifs of the flower may vary the colors from one blossom to another. In piecework tīfaifai, the same geometric designs may be repeated but varied through the use of different colors. Likewise, a geometric design such as a star, a square, or a triangle can be varied in size. For example, a piecework tīfaifai might have one large central star with several smaller stars surrounding it.

Finally, another artistic principle which women use in

creating tīfaifai is framing. Framing can be done in several ways. In many applique tīfaifai, a border design frames the central pattern. Borders may be very elaborate, such as those found in many Hawaiian quilts, or much simpler, as those in Society Islands style applique tīfaifai. Even if an applique design does not have a border, the width of the background fabric from the edge of the design to the edge of the backing fabric serves as a type of border or frame.

Piecework tīfaifai may also have two types of borders. As described before, a woman may make a border by folding and sewing the edges of the backing layer over the top, pieced design layer. Sometimes a border is created from pieces of fabric that differ from the central design in color and/or shape. Also, individual sections of an overall piecework design may be separated by borders.

2 Historical Development

The tīfaifai traditions of eastern Polynesia are less than two hundred years old. Yet, despite their relatively recent origins, tīfaifai have come to symbolize Polynesians' pride in their cultural heritage as well as to provide evidence of the islanders' ability to change. From the earliest tīfaifai, which shared many characteristics with Western quilts, to the diverse regional styles of contemporary times, tīfaifai reflect the combined influences of both Polynesian and Western cultures.

In the early nineteenth century, the people of Polynesia experienced their first prolonged contact with people from Western civilization. The implications were profound. Virtually every aspect of Polynesian life was affected or altered. Yet, to generalize that "the new replaced the old" is to oversimplify the actual processes

Fig. 17. A woman beating bark cloth in the Hawaiian Islands. Engraving by J. Alphonse Pellion, 1819.

of intercultural contact. The development of tīfaifai in eastern Polynesia characterizes how the Polynesians modified and incorporated foreign ideas and materials into their ongoing way of life, since tīfaifai originated as a result of Polynesian women's adaptation of Western quilting techniques, designs, and materials to their own past experiences in creating Polynesian bark cloth (Figure 17).

The first record of the introduction of quilting into Polynesia is from the Hawaiian Islands, where New England Protestant missionaries taught high-ranking Hawaiian women how to quilt. On April 3, 1820, seven young New England missionary women of the American Board of Missions held a "sewing circle" aboard the brig *Thaddeus*, which had recently arrived from America. Mrs. Lucy Thurston, one of the missionaries, recorded that four Hawaiian women of rank attended: Kalakua, mother of the young king, Liholiho; Namahana, her sister and a widow of the first Hawaiian king, Kamehameha I; and two wives of Chief Kalanimoku.

> Kalakua, queen dowager, was directress. She requested all the seven white ladies to take seats with them on mats, on the deck of the *Thaddeus*. Mrs. Holman and Mrs. Ruggles were executive officers, to ply the scissors and prepare the work. . . . The four women of rank were furnished with calico patchwork to sew,—a new employment to them. (Thurston 1882:32)

The act of sewing calico piecework was new to the aristocratic Hawaiian women, but the work patterns associated with quilting were not. The manufacture and decoration of native bark cloth, made from the inner bark of the paper mulberry *(Broussonetia papyrifera)* or other trees, was predominantly women's work.

With some local variation, the techniques of bark cloth manufacture were essentially the same throughout Polynesia. The islanders carefully cultivated and harvested the trees, after which the women peeled off the bark of the trees in one piece and separated the inner from the outer bark. After soaking the inner bark in fresh water or sea water, the women beat the inner bark with hand-held wooden beaters on a wooden anvil. This process broke down the bark fibers, stretched the bark, and made it more flexible. Depending on such variables as the type

of bark used, the amount of time the inner bark was soaked before beating, and the number and size of grooves carved on the beater, the resulting bark cloth could vary in texture from a very thick, coarse material to a soft and delicately thin material. Women often worked in groups when making bark cloth, and sometimes a leader directed the process.

When missionaries presented the quilt as a domestic art form requiring the efforts of a group of women, Hawaiian women easily adapted traditional work patterns to new skills. Missionaries probably first taught quilting to women of the royal households as a strategy to influence the general populace. However, Hawaiian women of rank, who had always created fine bark cloth and gained prestige from the work, may have thought it quite logical that they should be the first to learn quilting.

Specific documentation for the earliest introduction of the Western quilting tradition into other areas of eastern Polynesia is unavailable. In some cases, missionaries may have been the first to introduce quilting designs and techniques, but in some areas Polynesians themselves must have introduced the Western quilting tradition as a result of contacts with other Polynesians or Western missionaries on neighboring islands.

From such scattered evidence as historic photographs and early writers' remarks, it appears that piecework was the most commonly used style in the early phase of all regional tīfaifai and quilt traditions. Indeed, the term *tīfaifai*, "to patch repeatedly," retains the reference to the early style of piecework.

In the Society Islands, the Western piecework quilt may have been introduced by English women of the London Missionary Society, members of which first arrived in the Society Islands in 1797. However, visitors from the Hawaiian Islands, Tahitians visiting those islands, or even church workers who came later from the United States to the Society Islands may have introduced the piecework style. All of the earliest literary references and photographs of tīfaifai in the Society Islands are of piecework (sometimes called patchwork).

On January 8, 1858, M. G. Cuzent, attended a Tahitian wedding and recorded seeing piecework tīfaifai used as

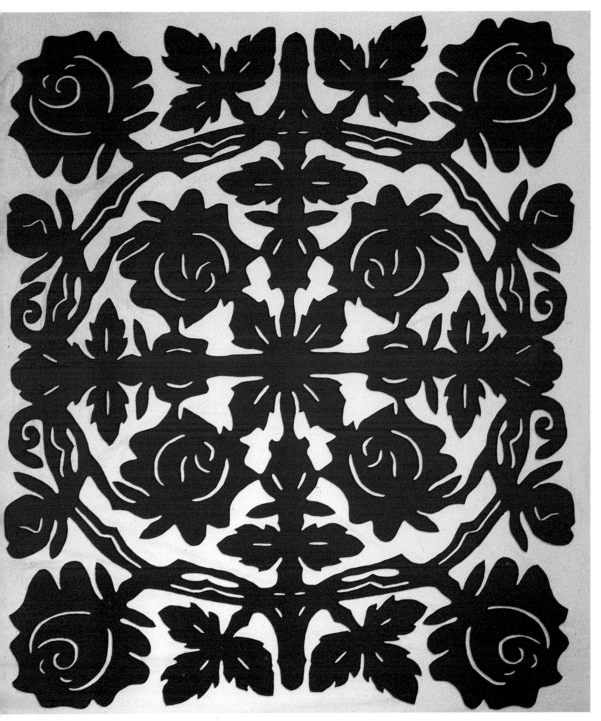

Plate 1. "Rose" (Rōti). Applique, tīfaifai pā'oti. Maupiti, Society Islands. ca. 1940. 97¾″ × 83″. Hand-sewn. Made by Josephine Taiuaroa.

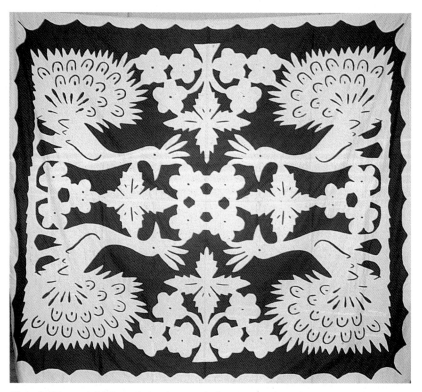

Plate 2. "Peacock" (Pitaote). Applique, tīfaifai pā'oti. Taha'a, Society Islands. ca. 1955. 97″ × 85″. Hand-sewn. Made and owned by Suzanne Ebb.

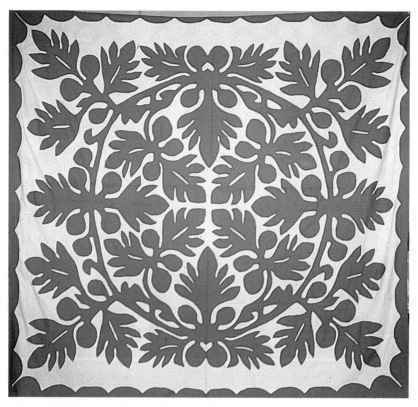

Plate 3. "Breadfruit" ('Uru). Applique, tīfaifai pā'oti. Taha'a, Society Islands. ca. 1955. 94″ × 83½″. Hand-sewn. Made and owned by Suzanne Ebb.

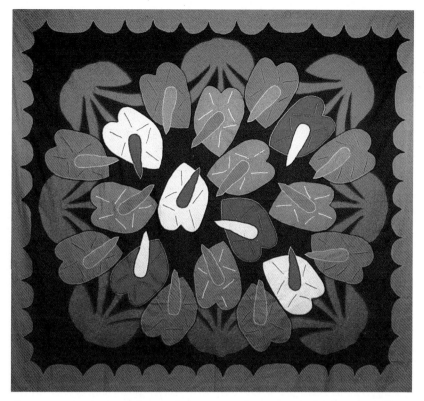

Plate 4. "Anthurium." Applique, tīfaifai pā'oti. Tahiti, Society Islands. 1978. 96¾" × 86". Machine-sewn. Made by members of a family-owned tīfaifai business owned and operated by Blanche Bellais.

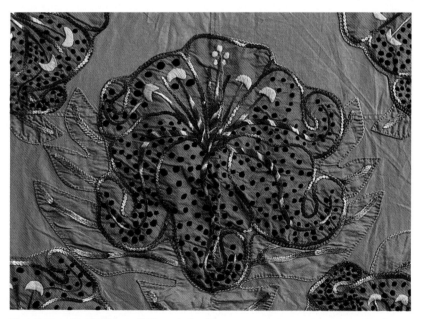

Plate 5. Detail of "Hibiscus" (Kaute). Applique, tīvaevae manu. Rarotonga, Cook Islands. ca. 1975. Hand-sewn. Made by members of the Arorangi congregation of the L.M.S. Church. Owned by Reverend Pittman and family. Embroidery has been used to outline the flower petals and create flower pistils and leaf veins.

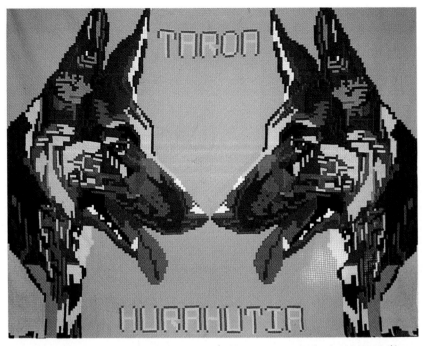

Plate 6. "Dog" ('Uri). Piecework, iripiti rima. Rurutu, Austral Islands. 1969. 126½″ × 97″. Hand-sewn. Designed by Temana Vahine and sewn by five women in the group Tamara Pupu. Presented by Temana Vahine as a gift to her three-year-old nephew whose name, Taroa Hurahutia, appears on the piece. The artist selected the motifs because the child loved dogs.

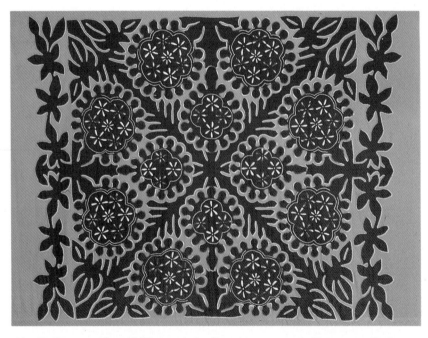

Plate 7. "Terevete Flower" (Terevete). Applique, tīvaevae manu. Rarotonga, Cook Islands. ca. 1970–1978. Hand-sewn. Created by a Women's Federation group and owned by the Rarotongan Hotel where it hangs.

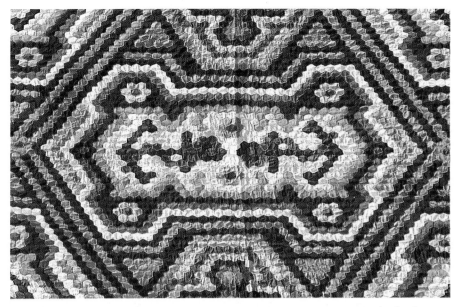

Plate 8. Detail of "Anchor." Piecework, tīvaevae paka'onu. Rarotonga, Cook Islands. Hand-sewn. Made sometime between 1930 and 1940 by Moeava Ruariki. The anchor motif may be based on an advertising logo of the Anchor Company of New Zealand, which exported evaporated milk to the Cook Islands.

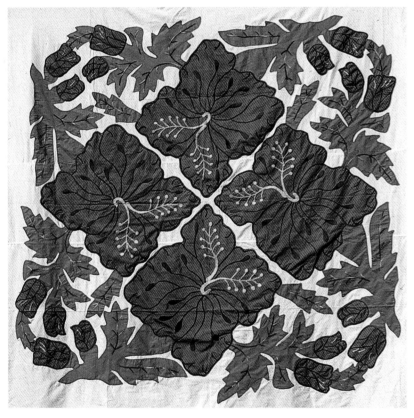

Plate 9. "Hibiscus" (Kaute). Applique, tīvaevae manu. Rarotonga, Cook Islands. 1975. 92" × 88". Hand-sewn. Created by members of the Arorangi congregation of the L.M.S. Church to present to Reverend Pittman and his family.

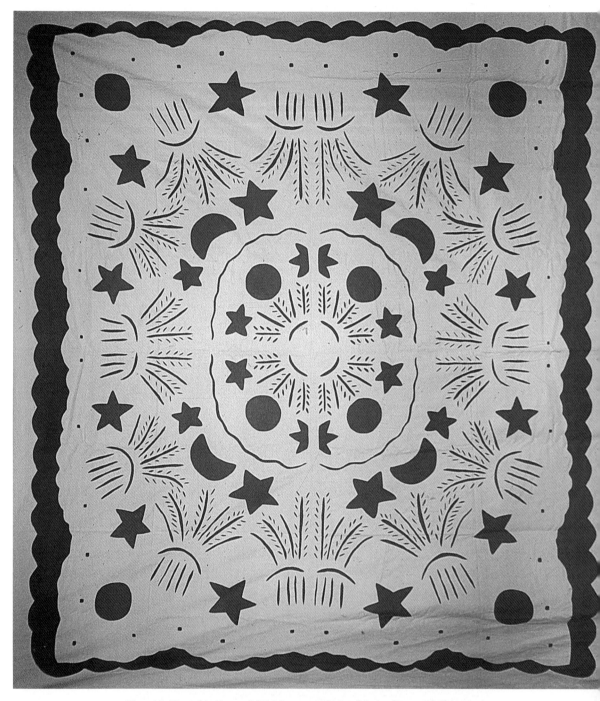

Plate 10. "Joseph's Dream" (Te Moemoeā Nō Iotefa). Applique, tīfaifai pā'oti. Tahiti, Society Islands. 1973. 94″ × 87″. Hand-sewn. Design created by a woman named Eugenie and sewn by relatives of the owner, Lilia Rari. The motifs in the inverse applique tīfaifai depict symbols of the famous biblical dream.

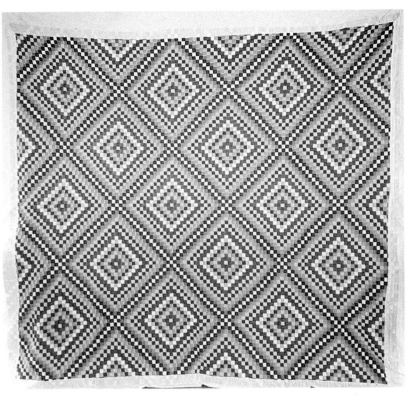

Plate 11. "Handkerchief" (Horoi). Piecework, tīfaifai pū. Tahiti, Society Islands. 1976. 103″ × 94″. Hand-sewn. Made and owned by Marguerite Perry Taarea. The original pattern for the tīfaifai belonged to the creator's grandmother. Each of the fabric squares in the tīfaifai is a little less than 1 inch square.

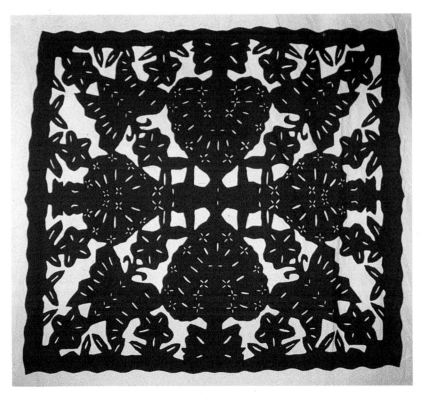

Plate 12. "Fans and Butterflies" (Tahirihiri et Papillon). Applique, tīfaifai pā'oti. Society Islands. Made before 1978. 98½″ × 84″. Hand-sewn. Made by Taroo Tufea. Owned by Teraimateata Tetauira.

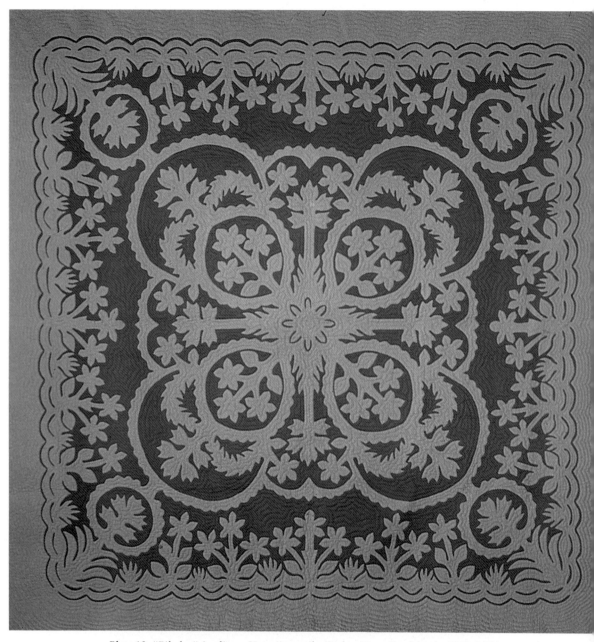

Plate 13. "Pikake." Applique, Hawaiian quilt. Oʻahu, Hawaiian Islands. 1962. 108″ × 108″. Hand-sewn. Made by Deborah (Kepola) U. Kakalia for her husband. Unlike many Hawaiian quilts that have a separate border design, the border of this magnificent quilt is attached to the central design. The distinctive style of Hawaiian quilting, which follows the outlines of the appliqued design, is an integral part of the overall artistry of the quilt.

decoration for the inside of the feast house *(fare tāmā'a-ra'a)* (Cuzent 1860:58–59). In 1877, Constance F. Cumming, who traveled to Tahiti with the Catholic bishop of Samoa, also recorded the use of tīfaifai as ornamentation inside a Tahitian feast house. Cumming's reference to the tīfaifai as "quilts" in the following passage is probably inaccurate and a reflection of her recognition of the close visual similarities between Tahitian tīfaifai and Western quilts: "Ere long we were summoned to breakfast—a native feast in a native house, which was decorated in most original style, with large patchwork quilts. These are the joy and pride of the Tahitian women, and so artistic in design as to be really ornamental" (1877, vol. 2:3–4).

Cumming also wrote about the tīfaifai which were placed on guests' beds: ". . . and such pretty coverlets of patchwork, really triumphs of needle-work. Those most in favor have crimson patterns on a white ground, but the designs are highly artistic" (1877, vol. 1:298–299).

It is not certain how and when Western quilts and quilting techniques were introduced to the Cook Islands. The piecework style may have been introduced some time after 1827, when the first European missionaries from the London Missionary Society arrived. It is also possible that a visitor to or from the Society Islands, the Hawaiian Islands, or the Austral Islands may have transmitted the Western-style craft.

Rurutuans were introduced to Western quilts in the nineteenth century through missionary activity, though probably not through Western missionaries themselves since the island of Rurutu did not receive them. Protestant missionary influence was probably transplanted by the wives of native Rurutuan ministers who traveled to the island of Tahiti for religious instruction in the latter part of the nineteenth century. It was most likely these women who brought needlecraft skills and the knowledge of making piecework to Rurutu.

Although Western piecework quilts provided models for the earliest forms of Polynesian tīfaifai, many of the design principles and construction techniques "borrowed" from the Western quilting tradition and accepted by Polynesian women were direct extensions of bark

cloth traditions applied to a new medium. Polynesian women often used relatively small geometric designs, regularly and symmetrically stamped or painted onto bark cloth. Likewise, they placed different areas of color beside one another in bark cloth, just as Western women did in creating piecework quilts. Finally, bark cloth and cotton fabric, though different, were similar enough materials to make possible similar construction techniques.

That the Hawaiians saw a correspondence between their indigenous bark cloth and the introduced Western quilts is reflected in the term *kapa*, which they applied to both bark cloth and Hawaiian quilts. Unlike other Polynesians, the Hawaiian women retained the three-layered construction of the Western quilt in their creations. They fashioned the top layer of a piecework quilt by sewing small pieces of cotton or other fabric together forming a relatively heavy layer of cloth. They placed a middle batting layer of fern "moss" *(pulu)*, cotton, wool, or even hair between the top layer and a cotton fabric backing layer, and then quilted all three layers together.

In eastern Polynesia, the construction of multilayered quilts is unique to the Hawaiian Islands. Though the construction techniques the Hawaiians use resemble Western quilt construction methods, there is strong evidence to suggest that these techniques were not based on entirely new ideas to the Hawaiians. In all likelihood, Hawaiian women copied the multilayered Western quilts and the techniques of quilting them in response to the same climatic conditions that formerly prompted them to make sleeping blankets or kapa consisting of several layers of bark cloth attached together at one end. Hawaiian women may also have adopted the actual quilting techniques of the Western quilt when they recognized the similarity between Western quilting designs and the watermark designs of nineteenth-century Hawaiian bark cloth created by pressing the carved side of a bark cloth beater against the damp material during the final stages of beating. Adrienne Kaeppler (1979:189) has noted: "Whereas barkcloth kapa has an overall watermark design which permeates the whole sheet and a second design printed on the upper surface, a kapa quilt has a

quilted design which is sewn through the entire quilt and another design appliqued [or executed in piecework] on the upper surface." (It should be noted, however, that the analogy is not strictly parallel since the watermark design was executed on bark cloth before the second design was printed on the upper surface, whereas a quilt design executed in piecework or applique is completed before the quilting is added.)

The designs most commonly created by Hawaiian women with quilting stitches on their piecework quilts included straight lines (diagonal and otherwise), diamonds, checks, and plaids (Figure 18). Although these designs were common to Western quilts of the same era, Hawaiian women had also used such geometric designs in bark cloth and in fiber mats. Other quilting designs (some of which are thought to be uniquely Hawaiian) may have been inspired by familiar objects such as fish nets, sea shells, fish scales, and turtle carapaces.

Hawaiian women probably incorporated both bark cloth and Western quilt designs in the piecework they created for the top layer of their quilts. Barrère (1956:16) believes women made Hawaiian quilt designs by copying the bark cloth designs created with the grooved bark cloth beaters (Figure 19). She contends that the bark cloth beater motifs known as *leihala*, *'upenuhalu'a*, and *ko'eau* evolved into the piecework quilt designs known as "Hala Blossoms" (Pua Hala), "House Gable" (Kala Hale), and "Bent Knee" (Kulipu'u) (Figure 20). However, the Hawaiians' selection of such designs was probably not without some Western influence. Designs similar to those on bark cloth beaters existed on Western quilts of the early nineteenth century, and it can be assumed that the missionaries had quilts with popular designs of the period among the household goods they brought to the Hawaiian Islands. Throughout eastern Polynesia, women may have been quick to accept those Western piecework quilt designs that were similar to the geometric designs they had used in bark cloth because the designs looked "familiar."

The piecework designs of many historical and contemporary tīfaifai throughout eastern Polynesia have counterparts in Western piecework quilts. Figures 21 and

Fig. 18. Historical Hawaiian quilting designs. *1, 2,* parallel lines; *3,* diagonal squares; *4, 5, 8, 9,* patterns perhaps taken from blocks of piecework designs; *6, honu ipu* ("turtle's back"), said to originate on the island of Kaua'i; *7,* shell pattern.

Fig. 19 *(opposite, top).* Patterns on Hawaiian bark cloth beaters.

Fig. 20 *(opposite, bottom).* Hawaiian piecework quilts on the floor of Our Lady of Peace Cathedral during the high mass held after the death of King Alphonso of Spain, January 1866. The quilt on the left is "House Gable" (Kala Hale) and the one on the right, "Bent Knee" (Kulipu'u).

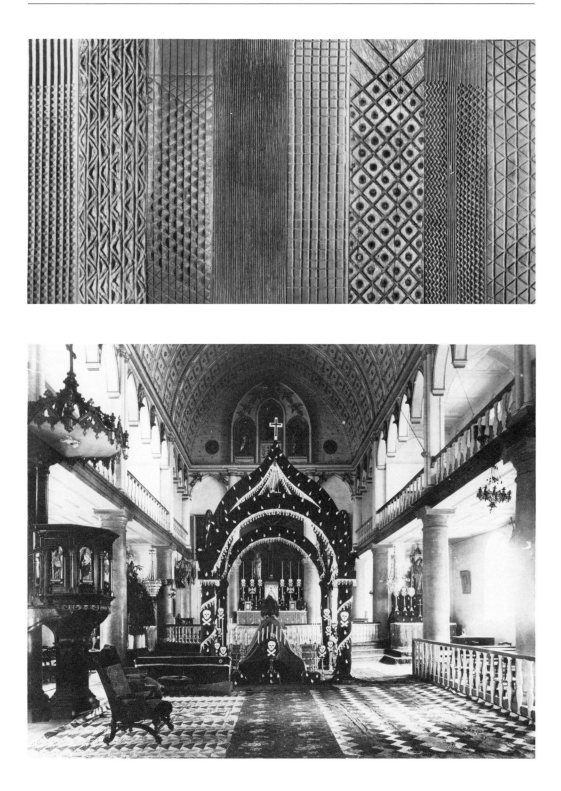

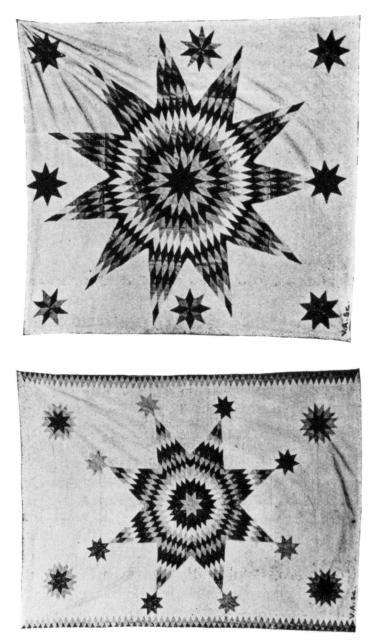

Fig. 21. Two "Star" (Etu) tīfaifai from Ra'iatea, Society Islands. Piecework, tīfaifai pū. ca. 1900. "Multicolored." Hand-sewn. (From Huguenin 1902:163)

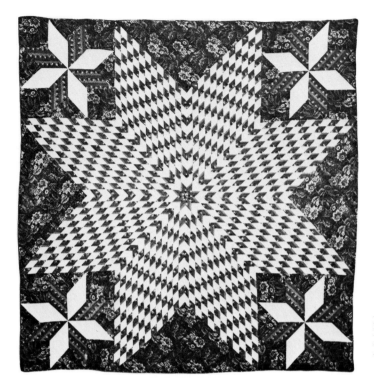

Fig. 22. "Star of Bethlehem."
Piecework quilt. New York.
ca. 1840. Blue and green print,
white, and brown floral print.
100″ × 100″. Hand-sewn.

22 illustrate the similarity in design between two turn-of-the-century Society Islands tīfaifai and an American "Star of Bethlehem" quilt made around 1840. Similarities between many Western quilt designs and eastern Polynesian tīfaifai designs are very striking, despite differences in color arrangements. Since many piecework tīfaifai designs with Western counterparts are common throughout eastern Polynesia, it seems very unlikely that the Polynesian designs were the result of independent invention or were transferred from one island to another through Polynesian influence only.

Polynesian women have often reinterpreted Western quilt designs in order to make them more meaningful to the islanders' experience. For example, a particular curved design known as "Drunkard's Path" in American quilt terminology is called Pā'aro in the Society Islands and the Austral Islands, the same name that islanders use for a special curved knife and for the act of using it to scoop coconut meat out of the shell.

Table 2. Eastern Polynesian Interpretation of American Design Blocks

Design Blocks	Society Islands	Rururu in the Austral Islands	Cook Islands	Hawaiian Islands
Nine-Patch	Horoi (Hand-kerchief) or Hu'ahu'a 'Ahu (Pieces of Cloth)			
Star of Bethlehem or Lone Star [1]	Feti'a (Star) or Etu (Star)	Feti'a or Etu	Eke (Octopus) or Etu	
Bear's Paw	Rimarima (Finger)			
Grandmother's Flower Garden, Mosaic, or French Bouquet	Pa'a Honu (Turtle Carapace) or Honu (Turtle)	Pa'a Honu	Paka 'Onu (Turtle Carapace)	
Baby's Blocks	Afata (Box)			
Streak o' Lightning, Zig-Zag, or Rail Fence	Fara'ē'ē (Ladder or Sawteeth)[2] or Ru (Zig-Zag)	Tūaina? (Unwound Rope)		Kulipu'u (Bent Knee)[3]
Pineapple	Painapo (Pineapple)	Painapo		

Table 2. *(Continued)*

Design Blocks	Society Islands	Rururu in the Austral Islands	Cook Islands	Hawaiian Islands
Drunkard's Path	Pā'aro (Coconut Knife, also a reference to the act of scooping coconut out of the husk)	Pā'aro		
Log Cabin	Pāhae (Tear, a reference to tearing the strips of fabric for the design) or Patu (Fence)	Patu	Patu	

NOTE: Some of the designs may occur in areas where I did not note their presence.
[1] Represents entire design.
[2] O'Reilly 1959:168.
[3] Jones 1973:61.

Just as regional interpretations of Western designs exist throughout the United States, so too there are many local interpretations of various piecework designs in tīfaifai throughout eastern Polynesia. Table 2 illustrates several variations of piecework names and the widespread distribution of certain designs. Hawaiian quilts are under-represented because the applique style enjoyed an early popularity in the Hawaiian Islands, and today piecework-style Hawaiian quilts are rare.

Although Polynesians have adopted many traditional Western quilt designs, transforming them into turtle shells, octopi, native flowers, and stars, they have also created piecework designs which have no Western counterparts. "Pandanus Fruit Garland" (Hei Fara), "Peacock" (Pitaote), and "Lamp" (Mōrī) are but a few uniquely Polynesian tīfaifai piecework designs.

Based on early historical documents and the presence of missionaries in the Hawaiian Islands beginning in 1820, it seems most likely that the Polynesian applique tradition originated in the Hawaiian Islands. Applique quilts appeared early in the history of Hawaiian quilting, quickly grew in importance, and soon gained a popularity

there that overshadowed the piecework style. Today, applique is the most common and popular style in the Society Islands as well, and is equally as popular as the piecework style in the Cook Islands.

The historical development of the Hawaiian applique quilt, like that of the piecework type, appears to be directly linked to characteristics of Hawaiian bark cloth. In her work on Hawaiian quilts, Edith Rice Plews (1932:2) recalls "my grandfather telling me that the kuina-kapa-papaʻu [an indigenous Hawaiian sleeping cover made from bark cloth] consisted generally of four white sheets of tapa and a top gaily colored and patterned one, all sewn together at one end, was a very warm and cozy covering."

Plews believes that the Hawaiian applique quilt descended from the bright outer bark cloth layer or *kilo-hana* of the *kuʻinakapa.* This idea is also supported by Jones (1973:11).

Historically, Hawaiian applique quilts were made in bold, contrasting colors. Greens and oranges on white, scarlet on gold, and printed calico on white were popular, but brilliant red on white was the most popular and prevalent color combination for early quilts. The choice of this striking color combination may be directly attributed to the basic red-on-white color scheme used for some of the decorated top sheets of bark cloth sleeping covers.

In addition to the characteristics of the Hawaiian applique quilt attributed to the bark cloth tradition, the applique style appears to incorporate elements of Western applique quilts, despite the claims of Jones and others that it is uniquely of Hawaiian origin.

Jones (1973:10), for example, cites practicality as one reason for her belief that the Hawaiian applique quilt was a Hawaiian innovation independent of Western influence. She asserts that the Hawaiians developed the applique quilt in the mid-1800s when money was fairly plentiful in the islands and calicoes and large seamless sheets were available. In her opinion, the Hawaiian women, who made their dresses from the full width of purchased cloth, found it more sensible to purchase widths of new material for quilts, since scraps for piecework quilts were not plentiful. She believes that it would have seemed "natural" to the Hawaiian women "accustomed each to her

own individual woodblocked patterns . . . to produce patterns of her own."

Although traditional work patterns undoubtedly did influence the Hawaiians' adaptation to new materials and techniques, it does not seem inherently more logical that the Hawaiian women would transfer their designing skills to inventing the applique style rather than to modifying the piecework style, since most bark cloth designs were geometric and not free-flowing forms characteristic of the Hawaiian applique quilt. Hawaiian women could have created their own unique piecework patterns by rearranging geometrical designs of Western quilts. In addition, they could have purchased new fabric and cut it into smaller pieces for piecework quilts as the women of Rurutu in the Austral Islands do today. Thus, questions of practicality were probably not the decisive factor in the development of the Hawaiian quilt.

In my view, the Hawaiian applique quilt probably represents the Hawaiian modification of Western applique quilts. Such quilts did exist at the time the missionaries introduced the more practical piecework quilt of everyday use. Although the applique-style quilts were undoubtedly less abundant, the missionaries probably had some to spread on their beds for special occasions, just as they had done in New England. There are many indications that the aura of prestige and wealth associated with the less common Western applique quilt may have influenced the Hawaiians in their selection of a quilt style to emulate.

Jones also discusses the distinctive manner of cutting a Hawaiian applique design to support her belief that the applique style was an original Hawaiian idea. Although the method of cutting an overall design from a single piece of fabric is unique to Polynesia, the Hawaiians may have developed the technique after seeing small Western applique designs created in a similar manner. There are American applique quilts which date to the period between 1836 and 1858, Jones' proposed dates for the origin of the Hawaiian quilt, which show striking similarities with Hawaiian applique quilts in the use of quadriaxial symmetrical designs and overall design arrangements with one central pattern or a central pattern with smaller

surrounding designs and a decorative border (Figures 23 through 30). The similarities in patterns and design arrangements suggest a strong Western influence on the Hawaiian applique tradition.

According to legend, however, the Hawaiian applique quilt was an indigenous invention. As related in one story, a woman traced the shadow of a tree's leaves onto a piece of cloth, cut the design out, and appliqued it to another cloth. Another explanation has been recorded by Jones:

> A woman who was a retainer of Kamehameha IV and Queen Emma is of the opinion that the Hawaiian method originated upon the birth of the Prince of Hawaii (1858), when the women began making quilts for the heir apparent. She said that on his first birthday a processional was held and the quilts were presented to the little prince. It is quite natural that on such an occasion the Hawaiians would turn to a more colorful and individualistic medium for expressing their joy than was afforded by the patchwork quilt. (1973:10–11)

Stories which emphasize the purely Hawaiian nature of the applique quilts are indicative of the importance that Hawaiians attribute to them. In their reinterpretation of the origin of the Hawaiian applique quilt, the Hawaiians have claimed the quilt as their own and through it are able to express pride and identification with a Hawaiian object. Thus, the Hawaiians' belief in the native origin of their applique quilts, together with their distinctive combination of motifs and contour style of quilting, make these quilts, in a very real sense, uniquely Hawaiian.

The Hawaiian applique quilt almost certainly had a direct influence on the origin and development of Society Islands applique tīfaifai. According to one Tahitian, in 1899 a woman named Lovinia Chapman brought several Hawaiian quilts to Tahiti, which were greatly admired. However, there is possible evidence that borrowing may have occurred previously. A photograph taken in 1885 shows Queen Marau, the Tahitian monarch, seated before a tīfaifai or Hawaiian quilt (Figure 53). From the photograph, it is very difficult to ascertain whether the work is of Hawaiian or Society Islands origin. The absolute proof of Hawaiian origin quilting is indiscernible. In addition,

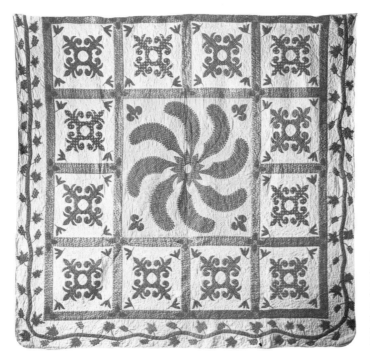

Fig. 23. ''Princess Feather.'' Applique quilt. Pennsylvania. 1860–1870. Red print and green on yellow. 88″ × 80″. Hand-sewn. Compare the twelve small motifs surrounding the central motif to the overall motif in the Hawaiian quilt in Figure 24.

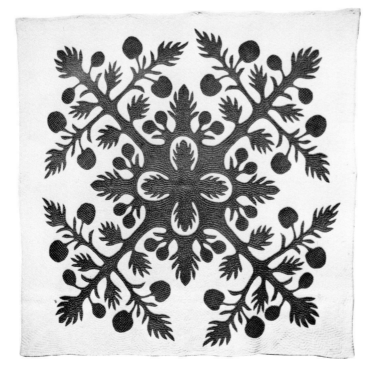

Fig. 24. ''Breadfruit'' (Ka 'Ulu). Applique, Hawaiian quilt. Maui, Hawaiian Islands. ca. 1910. Green on white. 83″ × 80″. Hand-sewn. Made by Mary R. Medinos for her children. This design shows similarities with designs pictured in Figures 23 and 25.

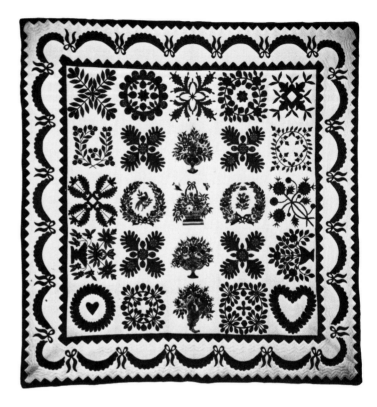

Fig. 25. "Album Quilt." Applique quilt. Maryland. ca. 1850. Red, green, yellow, pink, and white on white. 117″ × 117″. Hand-sewn. The small motif in the upper left-hand corner resembles the overall motif pictured in Figure 26, while the small motif diagonally below it is similar to the overall motif shown in Figure 24.

the design elements could be either Society Islands or Hawaiian. Whereas Society Islands applique tīfaifai have a rotational four-axis design, resulting from folding the fabric into fourths, Hawaiian quilts have a rotational eight-axis design. Even if enough of the tīfaifai or quilt were visible to see that there was an eight-axis design, the proof of Hawaiian origin would not be positive. It is possible, by paying special attention to the way in which the pattern is cut after folding the cloth into fourths, to create a Society Islands tīfaifai with an eight-axis design similar to the Hawaiian designs, which are created by folding the fabric into eighths. Furthermore, there is the possibility that early Society Islands applique tīfaifai were modeled directly on the Hawaiian style of cutting the eight-axis design. Indeed, the very similarity between the design principles and execution of the two regional styles suggests direct interisland influence.

In the Society Islands the development of the applique-style tīfaifai, like the Hawaiian applique quilt, was proba-

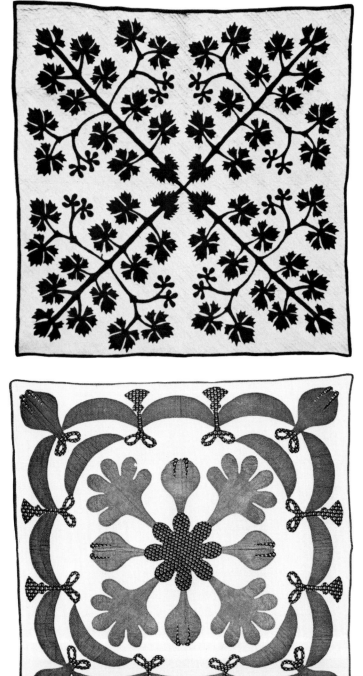

Fig. 26. "Grapevine" (Ke Kumu Waina). Applique, Hawaiian quilt. Hawai'i, Hawaiian Islands. Made before 1918. Red on white. 84″ × 84″. Machine-sewn. Compare the overall design to the small motif in the upper left-hand corner of the quilt in Figure 25.

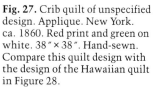

Fig. 27. Crib quilt of unspecified design. Applique. New York. ca. 1860. Red print and green on white. 38″ × 38″. Hand-sewn. Compare this quilt design with the design of the Hawaiian quilt in Figure 28.

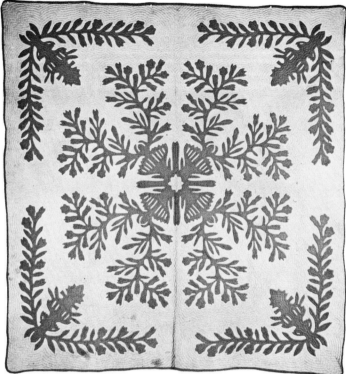

Fig. 28. "Press Gently" (Kaomi Mālie). Applique, Hawaiian quilt. Made before 1918. Blue on white. 85″ × 83½″. Hand-sewn. Compare this quilt design with the one in Figure 27.

bly influenced by the islanders' bark cloth. The Tahitians sometimes created distinctive designs by imprinting leaves dipped in red dye onto bark cloth (Figure 31). Although the arrangement of Society Islands applique designs of leaves and flowers is much different from the more random placement of bark cloth leaf impressions, the artistic principle expressed by applying an organic design onto a background is the same (Figure 32). Therefore, whether or not the Society Islands applique tīfaifai were directly influenced by the traditional bark cloth designs, the artistic choices arise from the same source.

The oldest examples of Cook Islands applique tīfaifai now extant were made around 1950 and closely resemble Society Islands applique tīfaifai of that era. Their designs, also, were made from fabric folded and cut into fourths, a fact that strongly suggests a Society Islands origin for the Cook Islands style. Contemporary Cook Islands applique tīfaifai created from separate pieces of fabric are very dif-

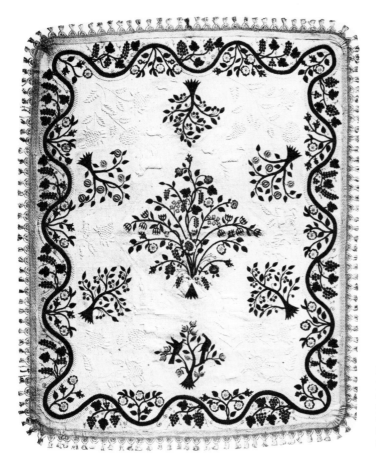

Fig. 29. Western applique quilt with stuffed-work or trapunto design. ca. 1840. Red, brown, yellow, green, and purple on white. 91″ × 78″. Hand-sewn. Compare this quilt's applique design with the one in Figure 30.

ferent in appearance from typical Society Islands applique styles today, but the basic artistic principle of symmetrical arrangement around the center of the tīfaifai remains the same.

The idea that extensive borrowing of tīfaifai designs and techniques took place among islands is supported by contemporary trends in tīfaifai traditions. For example, in the Cook Islands applique tīfaifai similar to the contemporary Society Islands applique style are sometimes created but more often are purchased on personal trips to the Society Islands. Cook Islands women value Society Islands applique tīfaifai as a distinctive and popular style foreign to their islands, despite the fact that Cook Islands applique tīfaifai probably originated from a Society Islands source over thirty years ago.

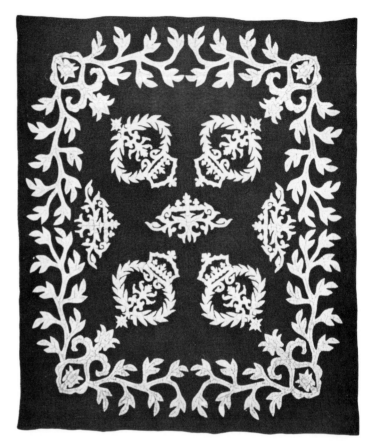

Fig. 30. "Crowns and Maile Lei" (Na Kalaunu Me Ka Lei Maile). Applique, Hawaiian quilt. Hawai'i, Hawaiian Islands. ca. 1880. Yellow on red. 72½″ × 68½″. Hand-sewn. Compare this quilt design with the one in Figure 29.

Fig. 31. Tahitian bark cloth with fern leaf impression designs.

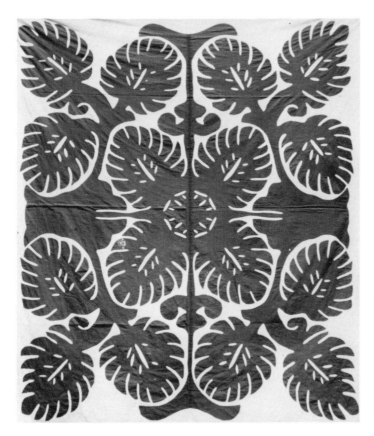

Fig. 32. "Serrated 'Ape Leaf" ('Ape Mahaehae). Applique, tīfaifai pā'oti. Tahiti, Society Islands. ca. 1965. Green on white. 90" × 85". Hand-sewn. Owned by Stella Ebb. Leaf designs appear on some Society Islands tīfaifai, reminiscent of fern-impression designs on Tahitian bark cloth.

Many women in Rurutu in the Austral Islands also purchase or receive tīfaifai from the Society Islands with whom Rurutuans share close social and political ties. Islanders of Rurutu usually distinguish the Society Islands tīfaifai from their own by calling the former tīfaifai and the latter iripiti. Though Rurutuan women sometimes consider the Society Islands tīfaifai more modern in appearance, most of them profess that their piecework style is more durable and beautiful.

In the Society Islands, and particularly on the island of Tahiti, there are tīfaifai of many regional styles. At artisan exhibitions, women who have immigrated from different island groups often display their work in adjoining, but separate, areas of the exhibition hall. Tahitian women, observing the differences, sometimes borrow elements of other regional styles in creating Society Islands tīfaifai.

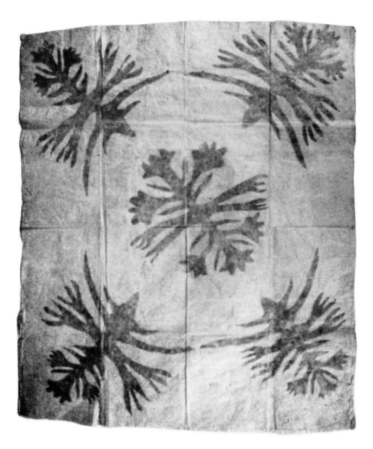

Fig. 33. Hawaiian bark cloth. Ascribed to the nineteenth century. Blue on light blue. The design on the bark cloth resembles Hawaiian quilt designs (see Figure 34) and was undoubtedly influenced by that art form.

As an art form influenced by both indigenous bark cloth traditions and the Western quilting tradition, eastern Polynesian tīfaifai and quilts have themselves influenced other forms of material culture, including bark cloth. Figure 33 shows a Hawaiian bark cloth ascribed to the nineteenth century. The design on the bark cloth closely resembles designs of Hawaiian quilts (Figure 34), illustrating this reversal of influence—from tīfaifai back to one of the art forms which influenced its development. Another example is an unusual Hawaiian *kapa moe* or bark cloth blanket from the island of Kaua'i (Figure 35), which also seems to take its inspiration from Hawaiian quilt designs. In describing the piece, Roger Rose (1980:176) has written: "Beaten or pasted onto the cover sheet, the applique designs resemble early quilts more

than the traditional kapa moe, suggesting an interesting cross-fertilization between the two arts." Elizabeth A. Akana's Hawaiian quilt shown in Figure 47 is an example of another kind of "cross-fertilization."

The influence of tīfaifai on the Western quilting tradition is most apparent in American quilting journals and various women's magazines. Aside from a few unusual reports on other regional styles, most of the information on eastern Polynesian tīfaifai traditions focuses on Hawaiian quilts. Americans have assimilated the Hawai-

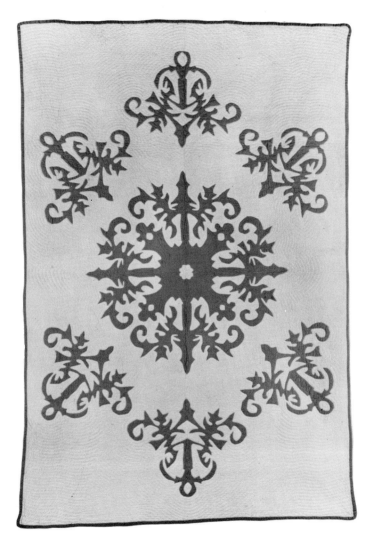

Fig. 34. "Niumalu Beauty" (Nani O Niumalu) or "Nāwili Beauty" (Nani O Nāwili). Applique, Hawaiian quilt. 1930. Green on white. 91″ × 61″. Hand-sewn. According to Plews (1973), this design was created by Mrs. George Montgomery to commemorate the new harbor at Nāwiliwili. Compare this quilt design with the design on the Hawaiian bark cloth in Figure 33.

Fig. 35. Bed cover *(kapa moe).* Kaua'i, Hawaiian Islands. Nineteenth century. Cut out fleur-de-lis and "snow flakes" in blue and salmon alternate with chains of interlocking hearts and other motifs in pink and blue. 290 cm. × 270 cm. This unusual kapa moe closely resembles Hawaiian applique quilts. The bark cloth motifs have been beaten or pasted onto the cover sheet.

ian quilt into Americana along with the lei and the hula. Hawaiian quilt patterns are often featured alongside traditional Western piecework and applique quilt patterns in American quilting magazines and needlework books.

Finally, tīfaifai designs have been used for a number of objects unrelated to the origin of the tīfaifai tradition. Hawaiian quilt designs have been duplicated on note cards, shopping bags, and posters. In Tahiti, merchants import from France and sell bed sheets with designs based on those of popular Tahitian applique tīfaifai. Tahitians themselves sometimes incorporate tīfaifai designs in special costumes for the French Independence Day activities held in July.

3 *Links to Tradition*

Although tīfaifai originated as a result of Polynesian contact with the Western world in relatively recent times, the art form is now an integral part of Polynesian cultural tradition. The appearance of tīfaifai in museums, hotels, and on postcards is testimony to the value which outsiders and islanders themselves place on them as "artifacts" of Polynesian cultural heritage. Tīfaifai have become symbols of Polynesian tradition because islanders use them to preserve and perpetuate their cultural heritage in three important ways. First, Polynesians use tīfaifai to replicate some significant functions of indigenous bark cloth. Second, tīfaifai are used to reinforce traditional cultural principles; and finally, they serve as symbols of cultural identification and pride.

Eastern Polynesians adopted Western cloth as a practical improvement over bark cloth and recognized it as an advance toward Westernization. At the same time, islanders prized Western cloth as a prestige item having multiple uses and some of the same attributes associated with bark cloth.

The importance of bark cloth derived from the many roles it played in the social and economic activities of the Polynesians. One of its primary uses was as clothing. Depending on the quality and amount of decoration, bark cloth had many uses, from everyday apparel to costumes for special ceremonies and purposes. Often, fine or decorated bark cloth indicated a person's social status. There were also bark cloth bed covers and room partitions. As room dividers, sheets of bark cloth sometimes served as mosquito nets, but they also lent privacy and beauty to the islanders' homes.

As a form of wealth, bark cloth was often bestowed upon people as a valued gift in birth, puberty, marriage, and death rituals. The presentation and exchange of bark cloth during rites of passage served to honor individuals and to validate and solidify the social and economic bonds among people participating in such rites.

Bark cloth played a major role in the religious ceremonies of many Polynesian societies. Islanders used special bark cloth to clothe wooden and stone deities, to hang

as pendants in places of worship, and even to represent certain gods.

With Western contact, people of eastern Polynesia began to replace bark cloth with Western material for clothing and most utilitarian household goods formerly made from bark cloth. Islanders were eager to obtain Western fabric, as Smith's account of the Tahitian sovereign Pomare II reveals. The king wrote, "Friends, send also property and cloth for us, and we also will adopt English customs" (Smith 1825:62).

When missionaries introduced Western quilts, eastern Polynesians admired them because they were made from brightly colored Western fabric and because substantial investments of time and much skill went into their making. Polynesian women created tīfaifai, drawing on the Western quilt tradition, to replace fine bark cloth in gift presentations to people of high status, in rites of passage, and in other contexts in which the giving of bark cloth had played a significant role.

Among those people of prominence honored with gifts

Fig. 36. Tīfaifai from the island of Takaroa, Tuamotu Islands. Piecework. Yellow, green, red, and white. 87″ × 65″. Hand-sewn. This tīfaifai was given to the Mormon missionaries Ernest and Venus Rossiter, who were stationed in Tahiti in 1915–1920 on their first mission of service in French Polynesia. The embroidered inscription at the bottom of the tīfaifai, "Te Aroha Teie No Te Amuiraa Tuahine I Takaroa" (With love from the "sisters" of the congregation of Takaroa), is dated 1918. Owned by Hinauri Tribole.

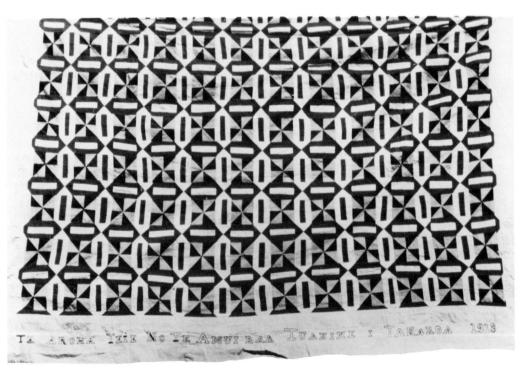

of tīfaifai were missionaries themselves. According to one account, "On Oahu [in the Hawaiian Islands] the Lima Kokua Society of young Hawaiian girls made a pieced quilt which they sent to the Bingham family, then conducting a mission station in the Gilbert Islands (1858–1868)" (Jones 1973:10). Missionaries of all denominations in eastern Polynesia have received tīfaifai, carefully created by women of the congregations and bestowed as a sign of affection and esteem from the entire congregation. Some tīfaifai are personalized with the recipients' or the donors' names. For example, piecework tīfaifai made in the Tuamotu Islands and dating to 1915–1918 were lovingly created and signed by Mormon converts for the missionaries Venus and Ernest Rossiter (Figure 36).

In contemporary eastern Polynesian societies, islanders sometimes present tīfaifai to government and church officials in the traditional manner: the islanders drape the tīfaifai around the recipient's shoulders. The practice of enveloping a high-status person with a tīfaifai has its origin in earlier Polynesian customs. Hawaiian islanders, for example, who identified Captain Cook as the Hawaiian god Lono, draped Cook with sacred red bark cloth in a special ceremony on the island of Hawai'i in 1779 (Figure 37). Tahitians presented Captain Bligh, famous as the commander of H.M.S. *Bounty*, with bark cloth in like fashion on his visit to Tahiti. James Wilson's account in *A Missionary Voyage to the Southern Pacific Ocean 1796–1798* provides a vivid description of the origin of the Tahitian custom of draping a tīfaifai around a person of high status.

> About four in the afternoon [March 13, 1797] Pomarre and his wife, Iddeah, having just arrived from Tiaraboo, paid their first visit at the ship; besides his usual attendants a number of others had put themselves in his train. When alongside he refused to come farther till the captain shewed himself; this being done, he immediately ascended the side, and coming on the quarterdeck, wrapped four pieces of cloth round the captain as his own present; then taking that off, repeated the operation with the like quantity in the name of Iddeah. (Wilson 1966:72)

As Figure 38 illustrates, the tradition of draping bark cloth around the shoulders of a high-status individual has

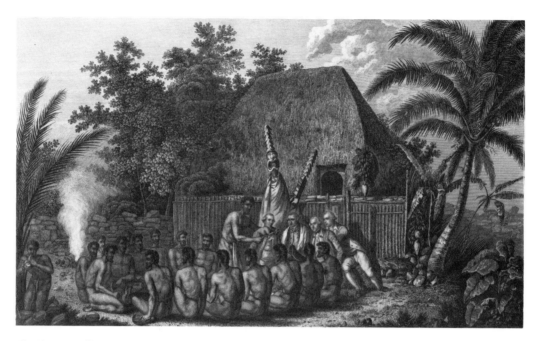

Fig. 37. "An Offering before Captain Cook." Engraving from a sketch by John Webber. 1779. Webber was an artist who sailed with Cook on his third voyage to the Pacific. Cook, who is seated just to the right of the tall wooden image, has a piece of sacred red bark cloth draped around his shoulders. The wooden image has been draped with bark cloth as well.

Fig. 38. The high commissioner of French Polynesia, Charles Schmitt, was wrapped in a tīfaifai on the island of Rangiroa in the Tuamotu Islands during an official visit in 1977. This practice recalls earlier customs of draping high-status individuals in bark cloth.

survived as a way of presenting tīfaifai. Islanders of Rangi-
roa in the Tuamotu Islands wrapped the high commis-
sioner of French Polynesia in a tīfaifai in 1977 on his offi-
cial visit to the island.

A different method of presentation among Cook island-
ers suggests close associations between historical and
contemporary ways of presenting gifts of bark cloth in
western Polynesia. Cook islanders ceremoniously display
the tīfaifai as they carry it unfolded toward the person
being honored. The donors may place the tīfaifai at the
feet of the recipient or partially drape it over the person as
he or she sits. A 1967 photograph (Figure 39) shows some
Rarotongans presenting a tīfaifai in this manner to the
Duke and Duchess of Kent on the royal English couple's
official visit to the Cook Islands.

Throughout eastern Polynesia, tīfaifai figure impor-
tantly in rites of passage ceremonies—those rituals which
emphasize and support physical and social changes for an
individual. Just as people once considered bark cloth a
highly esteemed gift to present to someone, today Polyne-

Fig. 39. Presentation of a tīfaifai
to the Duke and Duchess of
Kent. In 1967 the royal couple
made an official visit to Raro-
tonga in the Cook Islands. They
were ceremoniously presented
many gifts, including a piece-
work tīfaifai with a "Crown"
(Corona) motif. Note the
presence of the two tīfaifai
hanging behind the couple and
the tīfaifai draped over their
chairs.

Fig. 40. Tīfaifai displayed at a young woman's twenty-first birthday celebration on the island of Rarotonga in the Cook Islands, ca. 1975. Such birthday celebrations are often held in large buildings to accommodate the numerous guests at the feast. Rarotongan tīfaifai and tīfaifai imported from Tahiti are hung behind the table to honor the young woman in her new status. Tīfaifai are among the most valued birthday presents.

sians give presents of tīfaifai at births, birthdays, coming-of-age ceremonies, weddings, and funerals. Also, islanders sometimes use tīfaifai to decorate the area in which these rites are celebrated.

Close relatives often make or have made a tīfaifai to present to a child at birth or on the first birthday. In older Polynesian customs, the newborn infant was wrapped in a piece of bark cloth and the child's first birthday was honored with gifts of bark cloth, a custom still practiced in parts of western Polynesia. People bestow gifts of tīfaifai on other birthdays as well. In the Cook Islands, where people recognize the twenty-first birthday as the age of majority, tīfaifai often figure as gifts and decoration (Figure 40).

Tīfaifai play a prominent role in some coming-of-age rituals. In the Cook Islands, many islanders still observe a coming-of-age ceremony for boys. The rite is celebrated with a hair-cutting ritual called *pakotianga rouru*. A family who plans to celebrate the event allows the boy's hair to grow long from infancy. Usually people conduct the

ceremony for boys between the age of eight years and
early adolescence, but the family's financial resources
also help to determine the time. Individual guests take
turns cutting the boy's hair, which is bound into braids or
separate sections. The number of braids an individual is
entitled to cut is based on the amount of money and the
presents he or she gives.

Along with clothes and some personal items, people
often give the boy household articles which he and his
future bride will use when he matures and marries.
Tīfaifai sometimes figure among the presents that people
deem appropriate for the occasion. However, the most
impressive and important use of Cook Islands tīfaifai in
the ritual is for decorating the area in which the boy is
seated for the hair-cutting. Very often, the ceremony
takes place in a tentlike structure. Relatives create the
walls, ceiling, and sometimes even the floor with tīfaifai
(Figure 41). They may also cover the boy's chair with one.
Sometimes people drape the child himself with a tīfaifai
in a practice that parallels an older custom of honoring a
boy by placing a piece of bark cloth around his shoulders.

In the hair-cutting ritual, the tīfaifai that decorate the
area are also viewed as symbols of parental love. People
say that by using many valuable tīfaifai in the ceremony,
the parents honor their son.

Throughout eastern Polynesia, tīfaifai appear in wed-
dings more often than in any other ritual context. So
important are tīfaifai as wedding presents to the people of
Rurutu that the women create them for their children
long before the children are to be married. One woman
explained that by making the tīfaifai in advance, a mother
can avoid the worry that something may happen to her
before the wedding and thus leave her child without one
completed.

In other areas as well, friends and relatives often give
tīfaifai as presents. Relatives may place tīfaifai on beds
and sometimes on the walls of the homes members of the
wedding party will enter or sleep in. In many areas, peo-
ple decorate special wedding feast houses or banquet halls
with tīfaifai. Tīfaifai may hang behind the table of honor,
on the walls, and even on the ceiling (Figures 42 and 43).
The practice of covering the ceiling and walls of a feast

Fig. 41. Piecework and applique tīfaifai create a special setting for a 1973 Rarotongan hair-cutting ritual. The presence of the tīfaifai serves to honor the child. The individual braids on the boy's head are ceremoniously cut by relatives and friends.

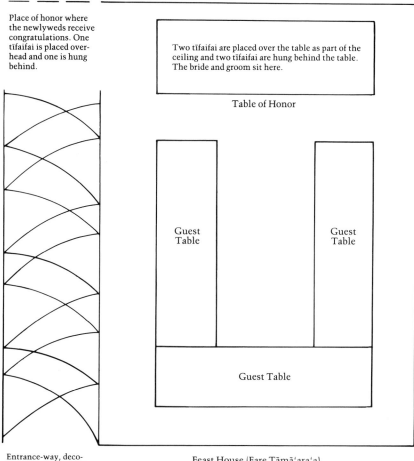

Place of honor where the newlyweds receive congratulations. One tīfaifai is placed overhead and one is hung behind.

Two tīfaifai are placed over the table as part of the ceiling and two tīfaifai are hung behind the table. The bride and groom sit here.

Table of Honor

Guest Table

Guest Table

Guest Table

Entrance-way, decorated with plants and flowers, which leads to the feast house and the newlyweds' reception area.

Feast House (Fare Tāmā'ara'a)

Fig. 42. Sketch of a "feast house" *(fare tāmā'ara'a)* for a wedding in Poutoru, Taha'a, Society Islands, in 1977. Note the placement of tīfaifai for walls and ceiling. Six tīfaifai, all of which were later presented to the newlyweds as wedding gifts, decorated the feast house to honor the couple. (See Figures 43 and 44.)

house with tīfaifai may have developed from an older custom of placing bark cloth over the heads of those for whom it was intended. O'Reilly (n.d.:7) states that bark cloth presented to individuals for services rendered was called tāpo'i (to cover), ". . . as the piece of cloth was spread out over the heads of those for whom it was intended."

In the Society Islands, people sometimes use tīfaifai at weddings to create a special setting, one where the unwed

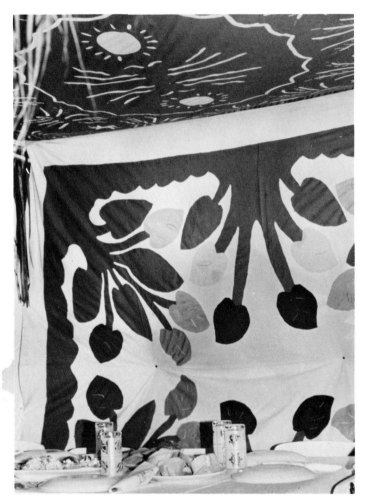

Fig. 43. Applique tīfaifai decorate a "feast house" *(fare tāmā'ara'a)* for a wedding on the island of Taha'a, Society Islands, in 1977. The two tīfaifai pictured, "Joseph's Dream" *(top)* and "Anthurium" *(behind the table)*, along with four others, served to honor the wedding couple. The tīfaifai were created by kinswomen of the groom, specifically for the wedding.

couple will make their entrance into public view on their way to church as well as where they will receive the congratulations of their guests after their vows. Figure 44 shows two generations of wedding couples standing beneath tīfaifai canopy structures.

The tīfaifai canopy may have originated in an earlier custom: "Another sheet [of bark cloth], called the tapoi [*sic*], was spread over the young couple who were still sitting and under it they remained a few seconds and received the first wedding greetings" (Oliver 1974:488–489). Although the Society Islands custom of placing a tīfaifai above and behind the marrying couple is different

from the earlier custom of placing a sheet of bark cloth over the heads of a newlywed couple, the similarity between the two is striking enough to suggest that tīfaifai replaced bark cloth in the ceremony.

Tīfaifai also figure in death rituals. Some people bury them with the deceased in the Cook Islands, the Austral Islands, and, to a lesser extent, in some of the Society Islands. The tīfaifai express the love, esteem, and personal loss felt for the deceased. Sometimes relatives place the deceased's favorite tīfaifai in the grave. In other cases, people sacrifice their most precious tīfaifai to express their feelings. In one instance, a woman from Rurutu sent several tīfaifai, originally intended as wedding presents for her son, to be buried with him in Tahiti. Since herself could not attend the funeral, the tīfaifai represented her personal involvement in the funeral services. The practice of burying tīfaifai with the deceased, once more common than today, may be traced to the custom of wrapping the dead in bark cloth. In parts of western Polynesia people still wrap their deceased in bark cloth.

Fig. 44. Two generations of wedding couples on the island of Taha'a in the Society Islands. The tīfaifai canopy-like structure serves as a place of honor. The wedding couple passes beneath it on the way to the church, and later, after the wedding service, stand beneath it to receive congratulations. The groom in the couple on the left *(a)*, who was married in 1977, is the son of the couple on the right *(b)*, whose wedding took place in 1950. Although the custom of erecting a canopy-like structure with tīfaifai is rather rare, some families maintain the custom, as these two generations demonstrate.

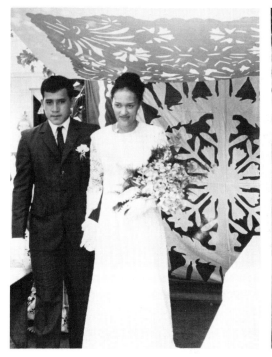 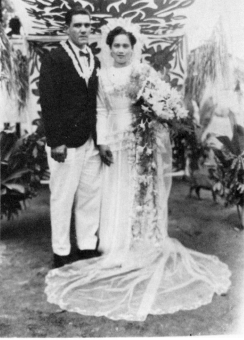

The role of tīfaifai in funeral ceremonies is especially important in the Cook Islands. Relatives and friends often strive to place several tīfaifai in the grave to indicate their esteem for the dead. People may place the deceased on one, wrap another around the body, and cover the body with a third. A folded tīfaifai may serve as a pillow. People sometimes add additional tīfaifai over the closed casket or even use them to line the grave vault.

In replacing bark cloth with tīfaifai in ceremonies, Polynesians have used the art form to preserve and reinforce traditional cultural principles. In particular, islanders express the importance of interpersonal relationships and social expectations through their fabric creations. It is not the tīfaifai as a material object that makes its value so great, although the cost of materials and the skill and time which women expend to make one are considerable. Rather, it is the personal and social meaning that islanders attach to tīfaifai which imbue them with such great worth.

Gifts of acknowledged value, tīfaifai serve to emphasize the importance of interpersonal relationships in material form. Throughout eastern Polynesia, for example, groups of female kin often work together to create tīfaifai wedding presents, which are offered as visible evidence of their kinship ties to the couple.

In designating how a gift tīfaifai should be used, islanders may further emphasize their message about interpersonal bonds with others. A Rarotongan minister's wife related how she and her husband were enjoined by members of their church to *use* a new tīfaifai that had been created as a farewell present for them. On the first night of their residence in a different home, the couple placed the tīfaifai at the foot of their bed, spread open for use. Although it was much too hot to utilize the tīfaifai that night, they carried out their donors' instructions as a way of verifying their social bonds.

In a similar manner, the ritual presentation of a tīfaifai at a wedding may enrich and illuminate the symbolic message of the tīfaifai in its role as a gift. For example, on the island of Rurutu, a wedding party assembles at a specially constructed feast house following the formal exchange of vows in church. After the wedding feast, rela-

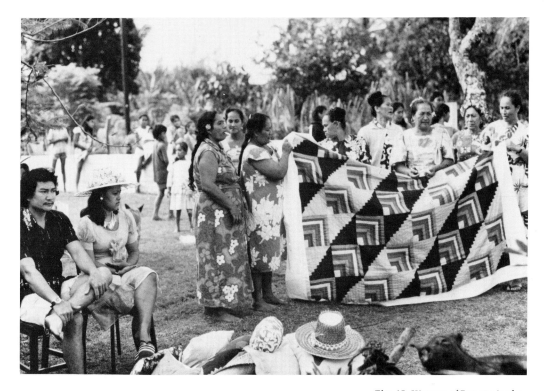

Fig. 45. Women of Rurutu in the Austral Islands about to wrap a machine-sewn tīfaifai around a marrying couple who are seated on the left. The kinswomen of the groom presented the gifts which are placed in front of the couple. They also provided the bride's clothing, hat, and jewelry.

tives present the bride and groom with large numbers of gifts as a spokesperson praises the generosity of the relatives and describes the bonds of kinship between them and the couple. After relatives have presented an assortment of gifts, members of the wedding party hold up an unfolded tīfaifai with which they encircle the bride and groom (Figure 45). If the couple has children by previous unions or a child by their own union previous to their marriage, members of the wedding party will also wrap the children in a tīfaifai (Figure 46). As the guests envelop the couple and their children with tīfaifai, they dance, chant, and sprinkle perfume and talcum powder on them to express their happiness and to give their approval of the couple's marriage.

The practice of wrapping a couple in a tīfaifai is an important element in the Rurutuan custom of *epa*, which includes all forms of honoring the newlywed couple. By wrapping a couple in a tīfaifai, the people of Rurutu symbolically "surround" the pair with feelings of happiness,

Fig. 46. A woman and her two granddaughters are wrapped in a tīfaifai during part of the children's parents' wedding ceremony on the island of Rurutu in the Austral Islands (see Figure 45). By wrapping the two half-sisters with a gift of tīfaifai, the community acknowledges and sanctions the children as part of the legal union of the parents.

love, and respect. The formal method of presenting the tīfaifai serves to bind the couple together as a unit. Symbolically, the act underlines the social, emotional, and physical union created by the marriage and emphasizes the couple as an entity distinct from other men and women. By wrapping a couple's children in another tīfaifai at the same time, wedding guests convey a message of public sanction and social approval of the children's position in the marriage.

If the wedding is not celebrated on the island of Rurutu itself, relatives may keep tīfaifai to be presented at a

subsequent "confirmatory ritual." Rather than simply
handing a tīfaifai to a couple already married, islanders
wrap them in the gift as though they were newlyweds.
This practice, which may take place years after the actual
marriage ceremony, suggests the symbolic significance
of the formal tīfaifai presentation as an opportunity to
express social approval for the institution of marriage and
to reaffirm interpersonal bonds.

One of the reasons that tīfaifai serve islanders of east-
ern Polynesia so well in perpetuating and preserving their
cultures is that the value and uses of tīfaifai parallel those
of the islanders' indigenous bark cloth. An anecdote
related by a Tahitian minister demonstrates the similari-
ties between eastern Polynesian tīfaifai and western Poly-
nesian bark cloth as contemporary symbols of cultural
pride and identity: Two young men from the Pacific
Islands, one from Tahiti and the other from the Tongan
Islands, attended a Pan-Pacific conference. As they
unpacked their suitcases to prepare their beds in the room
they were to share, the Tahitian noticed that his room-
mate had spread a piece of decorated bark cloth to cover
his bed, while he himself had brought a tīfaifai for the
same purpose. He looked from his roommate's bed to his
own and realized that, despite their differences, the bark
cloth and the tīfaifai were equivalent as valued symbols
of ethnic identification.

The significance of bark cloth and tīfaifai as symbols of
Polynesian culture and pride is combined in a unique
Hawaiian quilt created by Elizabeth A. Akana. Through
her quilt, "Kapa—A Study" (Figure 47), the artist makes a
visual statement of the historical connection between
bark cloth and quilts, as well as to their artistic and sym-
bolic similarities. Akana's quilt features design elements
that refer to the process of creating bark cloth (kapa). The
message contained in the quilt may therefore be viewed
as a tribute to bark cloth. For, at the same time that the
work draws attention to Hawaiian quilts as cultural
forms partially derived from bark cloth, the quilt also
focuses on bark cloth as an independent symbol of Hawai-
ian heritage.

Some of the most popular historical and contemporary
tīfaifai motifs depict other symbols of cultural identifica-

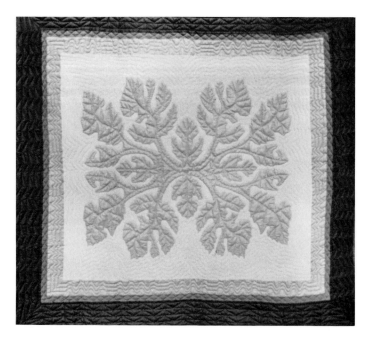

Fig. 47. "Kapa—A Study." Applique and piecework, Hawaiian quilt. Oʻahu, Hawaiian Islands. 1984. White, tan, green, and brown. 55″ × 50″. Hand-sewn. Created by Elizabeth A. Akana. This piece tells the story of how the *kapa* (quilt) and *kapa* (bark cloth) were used for Hawaiian bed covers. The central motif depicts the leaves of the tree from which bark cloth was created. The quilting designs in the quilt's borders duplicate the four patterns on the artist's heirloom bark cloth beater. The materials, construction, and design of the quilt (including the quilting designs around the central motif) refer to the heritage of the Hawaiian quilt as the art form which replaced bark cloth.

tion. In the Hawaiian Islands women have always based many motifs on symbols of the Hawaiian monarchy. Jones (1973) mentions several historical Hawaiian quilt motifs which honored the royal Hawaiian family, such as "The Comb of Kaiulani" (Ke Kahi O Kaiulani) and "The Pink House of Kalakaua" (Hale ʻĀkala O Kalakaua). Perhaps best known is the Hawaiian quilt motif called "My Beloved Flag" (Kuʻu Hae Aloha) (Figure 48). When the Hawaiian monarchy was overthrown in 1898, Hawaiian women created this motif to commemorate the monarchy's flag and coat of arms. According to some stories, one prominent turn-of-the-century family hung a Hawaiian flag quilt on the canopy of their four-poster bed and boasted that family members were "born under the Hawaiian flag" (Rose 1980:214).

Another popular historical Hawaiian heritage motif which women still create is "Crowns and Kahilis" (Na Kalaunu Me Na Kāhili), so called because it depicts crowns and feather standards, both of which were symbols of the Hawaiian monarchy. The Hawaiian quilt in Figure 49 entitled "Royal Symbols" is a variation of the

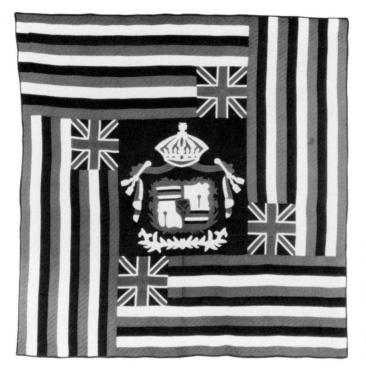

Fig. 48. "My Beloved Flag" (Ku'u Hae Aloha). Piecework and applique, Hawaiian quilt. Made before 1918. Red, white, blue, yellow, and brown. 85½" × 83". Hand-sewn. Hawaiian women created quilts of this type to commemorate the Hawaiian monarchy's flag and coat of arms.

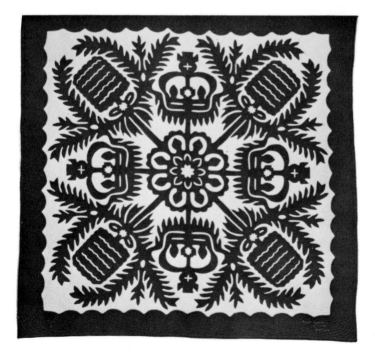

Fig. 49. "Royal Symbols." Applique, Hawaiian quilt. O'ahu, Hawaiian Islands. 1978. 78¼" × 77½". Hand-sewn. Created by Deborah (Kepola) U. Kakalia. The quilt's historical motifs are still popular as a reminder of Hawaiian history and cultural heritage because crowns and kāhili (feather standards) were symbols of the Hawaiian monarchy. The artist has also used the royal Hawaiian colors.

same motif and, like many others of similar design, is created in red and yellow, the colors of Hawaiian royalty.

Symbols of cultural identification also figure in innovative designs such as that depicted in Figure 50. This unique Hawaiian quilt, which simultaneously expresses pride in the Kamehameha Schools and in the Hawaiian heritage, utilizes the school's name, motto, and symbols, themselves drawn from Hawaiian history. In addition, the quilt's design replicates older quilt patterns and thus emphasizes the Hawaiian quilt itself as a symbol of Hawaiian culture.

Throughout eastern Polynesia, flowers are often chosen as motifs which strengthen cultural identification. Flower motifs, such as the "Tahitian Flower" (Tiare Tahiti) of the Society Islands, may be arranged as head or neck garlands which symbolize Polynesian love, hospitality, and festivity. In her distinctive quilt Kalehua-Wehe (Figure 51), Elizabeth A. Akana depicts a particular flower lei that is the subject of a Hawaiian legend. Kalehua-Wehe

Fig. 50. "A Name for Pauahi" (He Inoa No Pauahi). Applique, Hawaiian quilt. Oʻahu, Hawaiian Islands. ca. 1969. Blue on white. Hand-sewn. Designed by Mary K. Carvalho and sewn by Mealiʻi Kalama. This is the Kamehameha Schools Quilt. The chief's helmet and the school's motto, "Imua" (Forward), in the central medallion symbolize the strength and purpose of the great Kamehameha, the first king of the Hawaiian Islands, for whom the schools are named. A lei of kukui and mokihana, together with four hand kāhili (feather standards), form the border design of the quilt.

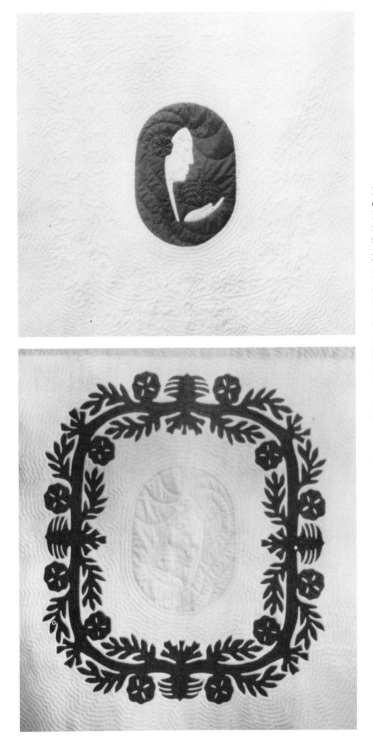

Fig. 51. Kalehua-Wehe. Applique, Hawaiian quilt. O'ahu, Hawaiian Islands. 1985. Dark red on white. 66″ × 58″. Hand-sewn. Designed by Elizabeth A. Akana, sewn by Kathy Dallas. *a:* The front of the quilt depicts the Hawaiian princess who accepted a lehua lei from a young chief, thereby breaking the taboo on surfing at Waikīkī. *b:* The back of the quilt shows the beautiful lehua lei that the princess accepted. The quilt is unique in having both sides as part of the overall design. The quilting designs, which appear on both sides of the quilt, assume different appearances as a result of the other design components. This highly unusual quilt reflects the innovative creativity associated with the Hawaiian quilt tradition.

is the name of a surf at Waikīkī on Oʻahu and is said to be
so named because of an incident that broke a taboo on
surfing at Waikīkī. A young chief from Mānoa removed
his *lehua* lei and gave it to Chief Kakuhihewaʻs daughter,
who until then had been the only one permitted to surf
there. The taboo was broken when the princess accepted
the lei (Pukui and Elbert 1971:114).

Other flower motifs are also associated with legends of
the islands. Their use highlights the tradition of storytell-
ing by recalling the legends in visual form. Both the
" ʻApetahi Flower" (Tiare ʻApetahi) of the Society Islands
and the "Naupaka Flower" of the Hawaiian Islands, for
example, are associated with love stories. According to
Tahitian legend, a beautiful woman cut off her hand when
her lover left her, and the hand grew into the distinctive
five-petaled *ʻapetahi* flower. Hawaiian legends surround-
ing the *naupaka* flower, which is similar to the ʻapetahi
flower in shape and looks somewhat incomplete, recount
that a beautiful princess tore the flower in half to give one
part to her lover whom she was forbidden to see again.
The tīfaifai motifs associated with such legends refer to
the stories as legacies of Polynesian heritage as well as to
the legends themselves.

The tīfaifai and quilts of eastern Polynesia also serve to
express to outsiders the Polynesiansʻ cultural heritage.
In the Hawaiian Islands, in particular, quilts and quilt
designs are often used as symbols of traditional Hawaiian
culture. Hawaiian quilt designs appear in many tourist
souvenirs. Advertisements for events that are supposed to
have a distinctively Hawaiian character may incorporate
quilt designs. Large organizations and companies some-
times commission quilts to display as symbols of Hawai-
ian heritage, and several hotels and public buildings have
them hanging in lobbies and meeting rooms. The pres-
ervation of Hawaiian quilts in various museums and
todayʻs numerous quilt exhibitions and quilting classes
also attest to the significance of the quilts as symbols of
Hawaiian culture.

Islanders use tīfaifai as symbols of cultural identity
when they present them as gifts to Western dignitaries or,
in the case of Cook islanders, to members of English
royalty. People may also display tīfaifai during national

events or holidays to assert their cultural presence within a political context which emphasizes the achievements of another culture or a larger political entity. For example, in the Society Islands tīfaifai figure in some of the festivities associated with the Polynesian version of French Independence Day. Beginning on July 14, islanders celebrate the Tiurai, named after the month of July, over a two- or three-week period with carnivals, dancing contests, sporting events, military marches, and tīfaifai exhibitions and contests. People may use tīfaifai to decorate parade floats (Figure 52), fair booths, and buildings where games of chance take place. The tīfaifai associated with the Tiurai serve as symbols of Polynesian cultural pride within the larger context of French nationalism.

Throughout eastern Polynesia, people use tīfaifai as an ever-evolving expression of cultural identity. In Pape'ete, Tahiti, a local beer company commissioned a woman to create a tīfaifai with the company's logo as the central

Fig. 52. A float for the annual festivities of the Tiurai, the French Polynesian version of French Independence Day celebrations, is decorated with tīfaifai to represent Pū Maohi, the artisan center in Pape'ete, Tahiti. The use of tīfaifai in this context serves to "advertise" the products of the group, and at the same time to provide a symbol of nationalism and cultural identity.

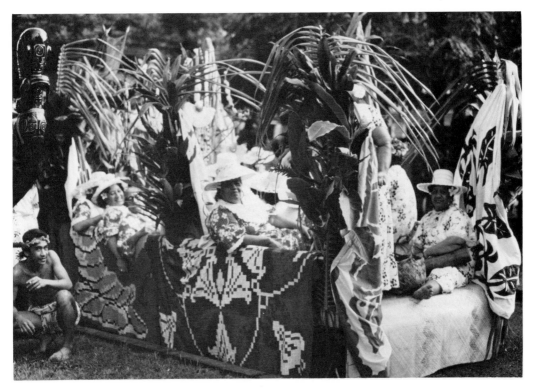

design. The company's advertising gimmick capitalized on the Society islanders' regard for tīfaifai as part of the Tahitian cultural heritage. Therefore, the tīfaifai effectively distinguished the beer company's product as a true Tahitian commodity.

In the future, tīfaifai may become increasingly more important as symbols of Polynesian culture if tourists continue to identify tīfaifai as Polynesian souvenirs and islanders respond by adapting to commercialization. However, as long as islanders continue to give them ceremonial and cultural importance, tīfaifai will remain symbols of cultural pride and identification significant to Polynesians themselves.

4 Adaptation and Change

At the same time that islanders have maintained indigenous values and reinforced cultural pride through tīfaifai, they have created and used tīfaifai to express their ideas about cultural change. As status symbols associated with the Western world, tīfaifai play a major role in expressing the Polynesians' acceptance of and adaptation to change.

From its introduction, islanders viewed Western fabric, from which tīfaifai are created, as a desirable and prestigious article associated with the power and wealth of the Western world. As previously indicated, islanders readily adopted the Western quilt, introduced by missionaries and fashioned from the highly valued Western fabric, as a fitting replacement for bark cloth in ceremonial contexts.

The creation and use of tīfaifai by high-ranking Polynesians added to the art form's overall importance as a prestige item and status symbol from the outside world. Lucy Thurston's account of royal Hawaiian women learning the art of quilting has been quoted in Chapter 2. In addition, several historic photographs record the display of tīfaifai by high-status Polynesians. Figures 53 and 54, for example, depict royal persons in the Society Islands photographed in front of tīfaifai.

The convention of posing before tīfaifai, deemed as prestige objects, is documented in other photographs as well. Figures 55 and 56 show two contexts in which Hawaiians proudly displayed their quilts behind them. In another photograph, taken in the Tuamotu Islands around the turn of the century, islanders are seated in front of tīfaifai during a Christmas program (Figure 57). Although the decorative function of the tīfaifai in this and many other contexts is unquestionable, the value of the tīfaifai as an object associated with the Western world is as important to an understanding of the photograph as the presence of the Christmas tree and the gramophone, other prized objects of foreign origin.

The association of tīfaifai with the wealth and power of the Western world is always an important dimension in the meaning of a tīfaifai, no matter how a tīfaifai is used. As a bedcover, its prestige value is manifest, not only

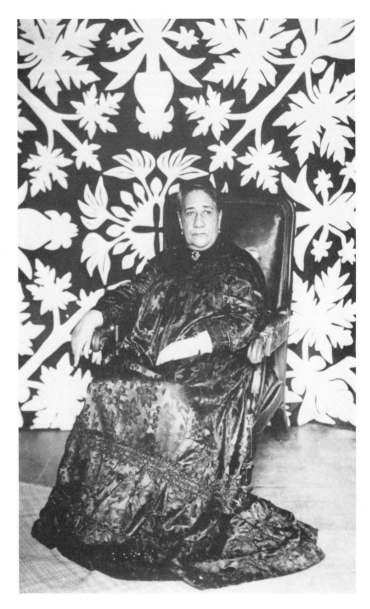

Fig. 53. Queen Marau, last of the reigning Pomare family of Tahiti, seated before an applique tīfaifai. This photograph suggests that tīfaifai have long been associated with high status and prestige. Eastern Polynesians have used tīfaifai to honor people in the same way that bark cloth once served that purpose.

Fig. 54. A royal family on the island of Taha'a in the Society Islands poses for a photograph in front of two piecework tīfaifai. ca. 1895.

Fig. 55 *(page 78, top).* Hawaiians proudly display their prized posessions in a pre-1900 photograph. Both an applique quilt *(left)* and a decorated bark cloth *(right)* were forms of wealth. The woman in the foreground sits behind a wooden anvil used for beating bark cloth.

Fig. 56 *(page 78, bottom).* Hawaiian hula dancers pose before a backdrop of two Hawaiian quilts.

Fig. 57. A photograph taken on the island of Niau in the Tuamotu Islands about 1909 shows two applique tīfaifai of similar design hung behind members of a Christmas program committee.

intrinsically in the tīfaifai itself, but also in its role as a display object on a bed, which is itself a Polynesian status symbol associated with Westerners. In 1957, Beaglehole reported that in a typical Cook Islands home

> a table, one or two chairs and at least one double bed with mattresses and pillows are considered necessary if one is to preserve one's minimum social status in the community. The bed is very often very elaborately dressed with fancy pillow cases, embroidered coverings and padded quilts. It is, however, rarely slept in since most people prefer to sleep on a mattress placed on the floor. (Beaglehole 1957:160)

(Beaglehole's reference to "padded quilts" is probably an error since there is no evidence that Cook Islands tīfaifai were ever quilted, either in the past or in recent times. The piecework tīfaifai are very heavy and thick as a result of the quantity of cloth used; perhaps to an untrained eye they would appear padded.)

Tīfaifai motifs offer further evidence of the art form's role as a prestige article tied to the Western world. Among the wide variety of motifs from nature, which predomi-

nate, are those based on plants and animals of foreign countries, for example, roses (Plate 1), pansies, cabbages, peacocks (Plate 2), and hummingbirds. The tīfaifai "Mermaid" (Meherio) displays one particularly interesting Society Islands motif. Based on the Western idea of a mythological creature that is part human and part fish, the mermaid combines elements of the natural world familiar to the islanders with elements of Western mythology.

Many objects introduced by or associated with foreigners have also been appropriated in tīfaifai designs. Polynesian women have used anchors (Plate 8), kerosene lamps, crowns, water glasses, Western and Chinese fans, and even linoleum patterns as motifs. From a historical perspective, islanders have always appreciated foreign objects as sources of inspiration. Jones (1973:13) reports that "any new design or subject that strikes the fancy may be reproduced on a quilt. The chandelier in the Palace when it was new was a favorite subject. The highly elaborate design in a stained glass window of the first parlor car in Hawaii was another."

In 1860, Cuzent recorded his observations of Tahitian tīfaifai with motifs based on the Prussian, Russian, and French eagle emblems (Cuzent 1860:58–59). The choice of foreign objects for tīfaifai designs, both today as well as in the past, is based on the prestige value of the objects themselves as foreign articles.

In addition to serving as status symbols associated with the outside world, tīfaifai help to integrate Western influences into the lives of Polynesians. Christianity is undoubtedly one of the most important Western institutions that have been assimilated into the fabric of Polynesian cultures.

As Christians, Polynesian women sometimes use biblical themes in their tīfaifai. In 1930, Jones recorded a number of biblical themes in Hawaiian quilts, including "Forbidden Fruit," "King Solomon's Porch," and "The Garden of Religious Light." A unique Hawaiian quilt (Figure 58) entitled "The Beautiful Unequaled Gardens of Eden and of Elenale" (Na Kihapai Nani Lua'ole O Edena A Me Elenale), created before 1918, juxtaposes the biblical theme of the Garden of Eden with a popular

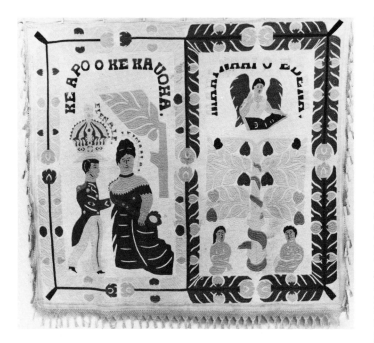

Fig. 58. "The Beautiful Unequaled Gardens of Eden and of Elenale" (Na Kīhāpai Nani Lua'ole O Edena A Me Elenale). Applique, Hawaiian quilt. Made before 1918. 92″ × 78½″. Handsewn. This unusual Hawaiian quilt by an unknown quilter has a design composition which may be likened to an open book. On the right side, under the legend "Garden of Eden" (Mahina'ai O Edena), is an angel holding what is probably an opened Bible. Adam and Eve sit beneath a tree around which the legendary serpent entwines. On the left side of the quilt are a man and woman identified as Elenale and Leinaala beneath the inscription "The Embrace of a Commandment" (Ke Apo O Ke Kauoha). Elenale and Leinaala were the principal characters in a popular romantic story in late nineteenth century Hawai'i. In the story, the beautiful Leinaala was held captive by a witch in Mānoa Valley and was rescued by the gallant Elenale who took her to live in his exquisite garden. The artist has depicted the main characters as a royal Hawaiian couple. Leinaala's pose and appearance resemble a lithograph of Queen Emma (1836–1885), and Elenale may therefore be assumed to represent King Kamehameha IV (1854–1863).

Hawaiian romantic story of the late nineteenth century. In the design, the main characters of the story, Elenale and Leinaala, appear as Hawaiian royalty. The combination of a biblical theme, a romantic story, and a reference to Hawaiian royalty within the same context represents one woman's unique interpretation of all three elements. Equating the royal Hawaiian couple with Adam and Eve, as well as with the lovers of a popular romance, implied in the quilt's design, serves as comment on the melding of foreign and indigenous ideas.

A popular contemporary Society Islands tīfaifai is "Joseph's Dream" (Te Moemoeā Nō Iotefa) (Plate 10). The design incorporates the biblical symbols of the moon, stars, and blades of wheat. Another contemporary tīfaifai motif that reflects Christian influence is Temana Vahine's "Jesus Messiah" (Iesu Mesia) shown in Figure 59.

Since Christianity has had an important influence on tīfaifai motifs, it is interesting to note that tīfaifai have likewise had a significant influence on the observance of Christian holidays. In the Society and Austral Islands, the first day of the new year, Matahiti 'Āpī, is celebrated as an

Fig. 59. "Jesus Messiah" (Iesu Mesia). Piecework. Rurutu, Austral Islands. 1963. Green, orange, pink, yellow, black, blue, maroon, red, and white on blue. 98″ × 96″. Hand-sewn. This unique tīfaifai is famous as the work of Temana Vahine who adapted the motif from a Western needlework book. Although the figure is Catholic in style, the motif is expressive of the artist's devotion to the Protestant church. The depiction of Christ seems particularly appropriate since this tīfaifai, like others, is used only as decoration for the home on New Year's Day and for the Mē, the two most important Christian holidays for people of Rurutu.

important Christian holiday. The new year is ushered in with such activities as drinking and dancing, but the observance of the new year also has many religious overtones which have origins in indigenous harvest rituals.

The Society and Austral islanders, the majority of whom are Protestant Christians, attend church on New Year's Eve. At midnight, the new year is rung in and people exchange best wishes. On the first day of January, it is customary for friends and relatives to visit each others' homes, sharing greetings and refreshments.

Society and Austral islanders decorate the walls and the beds of their homes with tīfaifai for the new year (Figure 60). This practice has replaced an older New Year's Day practice in the Society Islands. Henry (1928:177) reported that "some families, especially in Huahine, spread out upon lines in their homes tapa [bark cloth] which they placed at the disposal of . . . spiritual guests." The use of tīfaifai in the annual rites of the new year can

be viewed on one level as an offering of the "new" bark cloth to spiritual guests of Christianity.

Another context in which tīfaifai figure in the Christian religion adopted by the islanders is the Mē of French Polynesia. Based on the custom of the early Protestant missionaries' collections of tithes during the month of May, the annual ceremony of the Mē is still celebrated in the Society and Austral Islands. In the Austral Islands it is especially important and retains the same basic format of earlier celebrations.

On the island of Rurutu in the Austral Islands, the Mē, held on three consecutive Sundays during the month of May, consists of an annual tithe collection for each of the three villages of the island. The order in which the villages collect tithes is based on a rotating system. Each Sunday, members of a particular village give their annual tithes to the church during the day-long church service. Following the service, the people attend a verse and hymn meeting, the *tuāroʻi,* which lasts all night, and on the following Monday morning the people of the village open their houses to the members of church committees from the other two villages. The committee visitation serves as a health and building improvement inspection, but it is also a social event. Villagers welcome guests into their homes for refreshments, and guests visit the aged and ill on their rounds. During the third and final Sunday, people

Fig. 60. Piecework tīfaifai with a "Turtle Carapace" (Paʻa Honu) design placed on a bed on the island of Bora Bora, Society Islands, during the 1978 New Year's holiday. The pillows are made with the same techniques employed in piecework and applique tīfaifai.

from all over the island go to the last of the three villages where tithes are collected to attend the church services and the tuāro'i, as well as to visit the houses of the host village.

Several weeks before the Mē, the islanders thoroughly clean their homes, change the pandanus mats on their floors, hang new curtains, arrange artificial flowers and knickknacks on tables, and place many tīfaifai on all available beds. They may even place tīfaifai on walls and floors (Figures 61 and 62). All of these domestic prepara-

Fig. 61. Sketch of Temana Tane and Temana Vahine's Rurutuan home as it was decorated with tīfaifai for the 1978 Mē visitation of homes. In eastern Polynesian homes, beds often serve as decorative furniture. The six double beds pictured in the central living areas, for example, are ordinarily not used. During the Mē, all of these beds were covered with tīfaifai, and two were hung in the front room as well. Altogether, fourteen tīfaifai decorated the home, as indicated on the sketch in black. (See Figure 62.)

tions are for the ceremony of the entry into the houses
(tomo), a ritual in which members of a household stand
on the threshold and welcome visitors with calls of
"Come here!" *(Haere mai!)*, sprinkling their visitors with
perfume and talcum powder as they enter. The visitors
pass through all the rooms of the house, admiring the
cleanliness, industry, and decorations of the residents. As
the visitors leave through the back door, they help them-
selves to refreshments of cookies, oranges, pudding,
juice, and alcoholic punch.

Just as the islanders rededicate themselves to the Prot-
estant church during the Mē by pledging tithes, so too do
they renew personal and village ties when they welcome
guests into their homes, where they have placed tīfaifai
on display. Symbolically, therefore, tīfaifai express the
renewal theme of the Mē. Tīfaifai are carefully stored
through the years to ensure that they will always look
beautiful and new when guests see them.

Fig. 62. Four tīfaifai were
displayed in a symmetrical
arrangement on beds and walls
in the front room of the Temana
home in Rurutu in the Austral
Islands during the annual cele-
bration of the Mē in 1978.

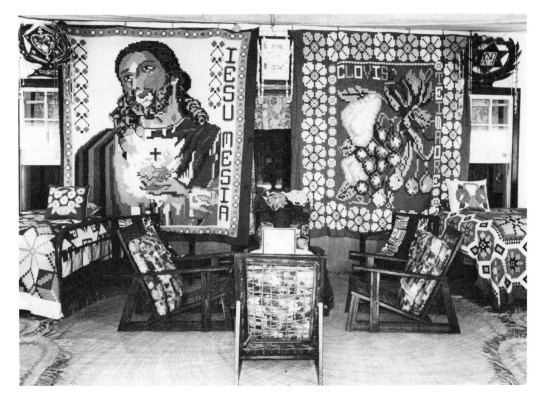

Although Society islanders once celebrated the Mē in a fashion similar to that of the Austral islanders, the role of tīfaifai in the Society Islands ritual has weakened through time along with other customs. However, one European missionary reported that in 1970 she and others visiting the island of Taha'a for the Mē were housed in a large building which was profusely decorated in their honor. Individual guest rooms were made by hanging tīfaifai to form walls, and the guests' beds were covered with tīfaifai.

In addition to their place in New Year's Day and Mē observances, tīfaifai appear in other Christian settings. A photograph of a church decorated with tīfaifai at the turn of the century (Figure 63) depicts the historical custom of using them to decorate places of worship. Islanders still occasionally decorate churches and associated buildings with tīfaifai for dedication ceremonies, conventions, and other special events.

The use of tīfaifai within Christian contexts seems particularly appropriate in light of the fact that missionary women were responsible for introducing the Western

Fig. 63. A 1901 photograph taken on the island of Raroia in the Tuamotu Islands depicts the lavish decoration of a church building with many piecework tīfaifai. The custom of decorating meeting halls, churches, and dining halls with tīfaifai is still practiced on some islands, and is derived from a previous use of bark cloth.

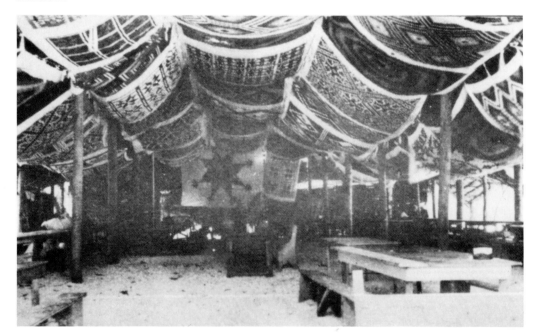

quilt from which tīfaifai derived. Tīfaifai may be seen as
"articles of faith" in the change which accompanied the
islanders' acceptance of the Christian religion from the
outside world. In the two most important religious holi-
days celebrated in French Polynesia, New Year's Day and
the Mē, tīfaifai serve as symbols of the islanders' accep-
tance of the Christian faith, and at the same time, of their
willingness to receive accompanying cultural changes.
The presence of tīfaifai in Polynesian homes during
Christian holidays communicates the islanders' affirma-
tion of forces which lie outside their own society and the
willingness of the people to acknowledge and integrate
those forces into their own traditions.

Another way in which tīfaifai serve as expressions of
cultural change and adaptation is in their roles as symbols
of progressive, "modern" behavior. They are displayed to
signify better life styles, especially in connection with
government-sponsored programs.

In the Cook Islands, an annual event called the Tutaka
revolves around a government-imposed health inspection
of islanders' homes. During one month every year, a
small group of doctors and health inspectors go from
house to house inspecting health conditions. In addition
to cleaning their homes and yards for the visits, Cook
islanders decorate their homes with many tīfaifai, placing
them on beds and hanging them on the walls. In this
annual event, introduced approximately sixty years ago
by the first doctors on the islands, islanders use tīfaifai
not merely as attractive examples of their industry but
also as prestige symbols associated with the progress and
modernization attributed to Westernization, of which the
Tutaka itself is an expression.

The Cook Islands Tutaka shares many elements in
common with the historical Pererina (pilgrimage) of the
Society Islands, which is, in turn, very similar in many
ways to the Mē of the Austral Islands.

> It [the Pererina] has many features. Some are entirely sec-
> ular, such as going around all the houses of a particular
> quarter or village in a "cleanliness inspection." This
> custom, innocent enough, and of the Tahitian heyday, is
> unfortunately dying out. The visiting party, made up of
> eight to ten people, minister, deacons, and a few guests,

> passes from house to house, having a glance at the upkeep
> of the furniture and the general cleanliness of the place,
> *the new patchwork counterpanes on the beds*, armchairs,
> seats, and bedsteads disappearing under thick multi-
> colored cushions. (Mauer n.d.:23, 26; italics mine)

Cultural change is reflected dramatically in the prac-
tice of selling tīfaifai for commercial profit. Women may
also sell tīfaifai to benefit specific organizations such as
churches and women's clubs, donating their time and
sometimes the material to make the tīfaifai, which they
may sell at bazaars or offer as prizes in raffles. In addition,
women sometimes sell tīfaifai that they enter in contests
or expositions.

During the past forty years, some women in the Soci-
ety Islands, especially in Pape'ete, Tahiti, have been
selling their tīfaifai directly to other islanders. Such
transactions occur in other areas of eastern Polynesia as
well, but today Society islanders (especially Tahitians)
and Hawaiians have access to the tourist market in addi-
tion to a local clientele. A Tahitian woman may sell
tīfaifai to tourists in the market or through artist coopera-
tives. However, the high cost of tīfaifai, due to the
expense incurred by women buying imported fabrics as
well as the labor involved, prohibits extensive marketing
to tourists. In addition, tourists are not as interested in
acquiring them as the local populace because the art form
does not have the same significance for foreigners as it
does for the Polynesians.

In the Hawaiian Islands, some women make quilts by
commission, and others place quilts in retail outlets. It is
not uncommon for a Hawaiian quilt to require at least a
year for completion. Therefore, the cost is prohibitive to
many tourists and the market remains small. Conse-
quently, the number of women who make Hawaiian
quilts for profit is also small.

Regardless of the way in which a woman sells tīfaifai,
that she does the work for monetary profit reflects the
islanders' accommodation of a cash economy, introduced
with Westernization. Thus, women who make tīfaifai
for personal profit contribute to the cash economy upon
which the changing cultures of eastern Polynesia are
dependent.

Selling tīfaifai for profit has affected style and construction methods in some areas. Although women throughout eastern Polynesia generally agree that hand-sewn tīfaifai are the most beautiful and best constructed, women who sell tīfaifai may use a sewing machine for the obvious reasons that it decreases their work time and allows them to work independently.

Women create both applique and piecework style tīfaifai on sewing machines, but they cannot duplicate some regional forms in this way. Hawaiian quilts and embroidered Cook Islands applique tīfaifai, for example, are two regional styles that are not easily adapted to machine sewing. It is not surprising, therefore, that in Tahiti, where machine-sewn tīfaifai are becoming increasingly more popular, many women sell tīfaifai, whereas in Hawai'i, very few women sell hand-sewn quilts.

Throughout eastern Polynesia, tīfaifai function to facilitate and express change in many ways. The vitality of tīfaifai as an art form adaptive to cultural change is witnessed in the historical and contemporary forms and their varied uses. The contemporary Tahitian radio commercial advertising a certain type of sewing machine that can produce a well-made tīfaifai is but one example of increasing testimony to the continuing importance of tīfaifai and the adaptability of the art form to technological and social advances.

5 *Personal Expression*

Women design, create, and distribute tīfaifai. Despite the fact that men occasionally design tīfaifai and even more rarely sew them, Polynesians agree that the tīfaifai tradition belongs to the realm of feminine achievement. Women find personal satisfaction in the creative process and in the recognition and prestige they receive as artists. They strengthen family ties by presenting gifts of tīfaifai to relatives, and they forge interpersonal bonds with others when they make tīfaifai in groups. Women also use tīfaifai as symbols of their feminine roles and through them are able to extend their influence beyond their homes into areas of public concern. In short, women throughout eastern Polynesia create and use tīfaifai to express their identities as individuals and as members of various organizations and groups.

There are three ways in which a Polynesian woman may use tīfaifai to express herself. She may communicate personal information through her decisions concerning work patterns, artistic choices, and uses for tīfaifai. Each of these areas provides unique opportunities for self-expression. Within each decision-making area, a woman is able to communicate a wide range of meanings. By making decisions in more than one area, however, she greatly expands the possibilities inherent in using tīfaifai as a symbol of herself. Furthermore, a woman can expand her possibilities for communicating her sense of self over time by engaging in one or more areas of decision making with many tīfaifai. Thus, a woman has many options for utilizing tīfaifai as a symbol of self. The dynamic aspect of her decision making enables a woman to communicate a sense of the richness and complexity of the many roles she holds.

In the past, many women of all ages made tīfaifai. They sometimes learned from friends or by simply observing the art, but most of the learning process took place in the family. Mothers, grandmothers, and aunts taught young girls to make tīfaifai. As the following story indicates, the teaching was at times selective.

When Josephine Leimalama Kamakau Hanakahi was growing up in Paia, Maui, her mother made Hawaiian quilts and gave one to each of her six brothers and sisters but none to Josephine. "Mama, what about me?" the child asked. Her mother replied, "My gift to you is teaching you the art of kapa ku'iki" [Hawaiian quilting]. (Altonn 1975, p. B4)

Over the years, fewer women have pursued the skills requisite for creating tīfaifai. Although some schools teach Polynesian girls to make tīfaifai as a part of the curriculum, many young Polynesian women never learn to create them and express no desire to acquire the skills. In addition, many mature women either disavow any ability to create tīfaifai or express disinterest. Therefore, a woman's decision to make tīfaifai alone or within a group context (Figures 64 to 67) is an expression of her own desire and not a submission to societal pressure to conform to a feminine role.

While the decision to work alone on a tīfaifai may reflect a woman's self image as a person who must accommodate herself to established roles (as, for example, in the case of women who prefer to work independently because they feel they cannot find time to work with others), in most cases, a woman decides to work alone so that she can control decision making in artistic choices, tīfaifai uses, or both. She may work by herself to express her identity as an individual artist, an independent agent in social contexts, a self-employed business woman, or a combination of these roles. Many women work independently because they wish to have complete control over all aspects of the creative process. They often say they prefer to work alone to ensure uniformity in their tīfaifai. How the tīfaifai shall be used, whether for personal use, as a gift, or item for sale, is often decided with control of artistic choices in mind.

In Tahiti, many women sell tīfaifai to local clients, and this often involves a two-step individual creative process. The seller buys the fabric and then cuts and bastes the applique design onto the background material. The buyer herself sews the tīfaifai or commissions another woman to perform the task.

Fig. 64. Marie Taurua, a famous Tahitian artist, pins the design of a "Mermaid" (Sirenes or Meherio) tīfaifai onto the background fabric. The applique design will later be basted and then sewn to the fabric.

Fig. 65. A mother, daughter, and friend on Rurutu in the Austral Islands complete the final stages of creating a piecework tīfaifai by pinning the design layer to a backing fabric and sweeping loose threads from the surface. The mother has incorporated her son's name into the tīfaifai and will present it to him when he marries. Prior to the wedding, she will display it in her home on special occasions.

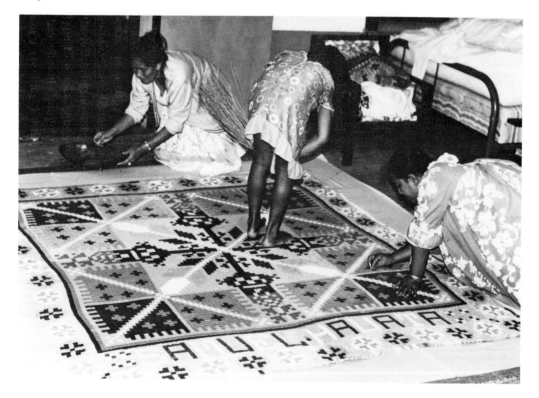

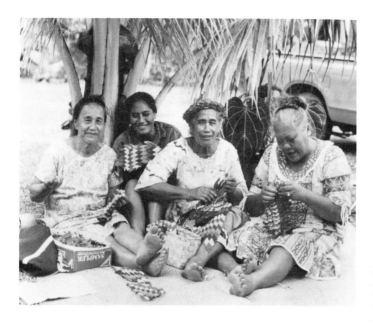

Fig. 66. Rarotongan women of the Cook Islands work on a piecework tīfaifai together as members of a congregation.

Fig. 67. Women of Rurutu in the Austral Islands machine stitch several tīfaifai which will be used as wedding presents. Kinswomen often work together on such projects.

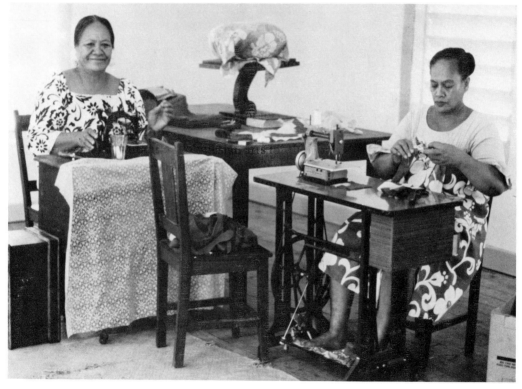

While there are women who always work alone, many women make some of their tīfaifai within a group. In terms of practical considerations, a woman who works within a group can expect others to contribute their time, labor, special skills (and, in some instances, fabric) to the creation of a tīfaifai. The emphasis on sharing resources with others allows a woman to support members of the group and their common goals, to express her generosity, and to exhibit her skills.

Groups vary in their approach to making tīfaifai. In Rarotonga, one women's group divides the work into equal portions for each member. Members share work in each tīfaifai created, and each woman takes her turn in receiving a finished one. As a result of this arrangement, several women own the same design.

In Rurutu, a group of women from the same village trade skills with one another on a round-robin basis in order to produce different kinds of handcrafted articles, such as purses, hats, and mats, to sell or use for their own purposes. Three or four women under the direction of a skilled creator also make tīfaifai on request for other group members. A woman who wishes to trade her labor for a tīfaifai may do so by participating in the group's activities. Although she must purchase the fabric, she exchanges her handicraft skills for the labor of those women best qualified to make her tīfaifai.

In Tahiti, some women organize small groups whose members take turns receiving a tīfaifai. Only one woman may actually create it, but the members contribute a small sum of money on a regular basis to purchase the materials. The creator herself takes her turn in receiving a finished one.

Although a woman may join a group primarily for practical reasons, most women also choose to create tīfaifai within a group context in order to be members of a particular group. Women who form such groups often do so on the basis of work, neighborhood, and church affiliations; their kinship and friendship bonds; and their alliance with others who have similar interests. In many cases, organizing principles overlap, as, for example, women who are friends as well as members of the same congregation.

By joining others in the common goal of creating tīfaifai for a specified purpose, a woman can express personal convictions and strengthen interpersonal bonds. She indicates to people within and outside the group that she has certain things in common with the other members. She may also gain respect, prestige, and status within the membership, since women with special talents for designing, sewing, and organizing often receive praise from others within a group.

At any given time, a woman may belong to more than one type of group—perhaps one that occasionally creates tīfaifai and another that is organized solely for that purpose. During her lifetime, a woman may belong to many groups with different organizational principles and purposes. Her affiliation with one or more groups and her position within a group as chief decision maker, primary organizer, or fellow seamstress often reflect her roles in societal contexts outside the group and serve to strengthen them.

A second way in which women may use tīfaifai as a vehicle for self-expression is in making decisions involved in artistic choices. A woman makes an artistic decision every time she elects to use a particular design, construction technique, sewing method, fabric, and color combination.

Polynesians greatly value creativity in tīfaifai. Although careful stitching and construction are essential for any well-made tīfaifai, most Polynesians agree that creating a design is the most difficult aspect and the one that requires the greatest skill. For that reason, Polynesians regard women who are highly competent in all aspects of creating tīfaifai as experts.

Women place greatest emphasis on individual creativity in decisions about designs. As a symbol of self, the tīfaifai is often viewed as an extension of its creator. For this reason, Polynesians adhere to an ethical code which safeguards the originality of a woman's design. Polynesians recognize the creator as the rightful owner of her design to share or keep as she pleases.

A woman may take special measures to guarantee her "rights" over the design. One woman in Rarotonga said that a woman must register a tīfaifai design with the local

governmental officials to "patent" it. Although local
authorities say that such a procedure doesn't exist, the
woman's statement indicates her strong feelings about
the importance of originality.

Some women create only one or a few tīfaifai with a
particular design and then destroy the pattern in order to
preserve the originality of the design. One Tahitian
woman recalled that her mother made three tīfaifai with
a basket-of-fruit motif. After giving the tīfaifai to her
daughter, a cousin, and a close friend, the woman de-
stroyed the pattern, thus ensuring the uniqueness of her
gifts.

Contemporary Hawaiian women sometimes create
an artistic "signature" for themselves by incorporating a
distinctive feature into all of their quilts. For example,
one famous Hawaiian quilter introduces an eight-pointed
star into all her quilt designs (Figure 68). Another uses an
unusual hook motif as an identifying device.

Although Polynesians emphasize originality in the
design of a tīfaifai, a woman can claim originality by
modifying a popular pattern commonly known to all.
Throughout eastern Polynesia, there are a number of pop-
ular motifs which provide women with the inspiration for
an endless variety of individual design interpretations.

The creation of highly original designs appears to be
more prevalent in the Hawaiian Islands than in other
areas. This may be attributed to a long-standing tradition
in Hawaiian quilt making for abstract and nonrepresenta-
tional designs which bear names such as "Press Gently"
and "The Wind that Wafts Love from One to Another." In
addition, the ethical code of preserving originality has
always been especially important to the Hawaiians. Orig-
inality, however, was sometimes expressed in unusual
ways. Akana (1981:43) states: "Many early Hawaiian
quilters borrowed each others' patterns with the under-
standing that the name of the work would be changed.
Hanohano Hawaii Lei Kalehua, 'Glorious Hawaii Lehua
Lei,' is the same design as Na Lei O Hawaii. Still a third
quilt with the same design is called Liko Lehua O Pana-
'Ewa, 'Lehua Buds of Pana-'ewa.' " According to Jones
(1973:12–13), in the past, Hawaiian women sometimes

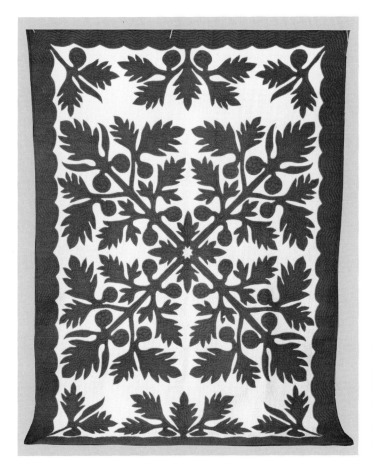

Fig. 68. "Breadfruit" (Ka ʻUlu). Applique, Hawaiian quilt. Oʻahu, Hawaiian Islands. 1978. Green on white. 108″ × 76″. Hand-sewn. Deborah (Kepola) U. Kakalia designed and created this quilt by commission. The artist's signature, a cut-out eight pointed star, appears in the very center of the design.

composed songs in which they derided others who copied their quilt designs. Many Hawaiian women did not display their quilts until they were completed, in order to prevent anyone from imitating their original work. As a result of the emphasis on originality, many women closely guarded their patterns and shared them only with close friends or family members. Even today, many Hawaiian women are reluctant to have their quilts photographed.

In addition to using tīfaifai as a vehicle for demonstrating her unique artistic abilities and aesthetic sense, a woman is able to express many personal feelings and ideas through her decisions about tīfaifai designs. A

woman may give personal expression to a particular design by using it as a private symbol whose full meaning may be known to only a few people or to the creator alone. For example, one Hawaiian grandmother, who made a different quilt for each of her grandchildren, created one with a breadfruit motif for a granddaughter who, as a small child, had enjoyed eating an unusually large amount of breadfruit.

A Society Islands woman who directed several kins-women in creating four tīfaifai for her son and daughter-in-law as wedding presents chose to make one of them with a design of a pandanus fruit garland because, as she explained, islanders make decorative head wreaths or crowns from the pandanus fruit which they wear on festive occasions. As a personal message, she chose the "Pandanus Fruit Garland" (Hei Fara) because she thought of her son as a crown that glorified her.

Descriptive names associated with a particular design may also carry hidden meaning. Deborah (Kepola) U. Kakalia, a renowned Hawaiian quilter, made a taro plant design quilt which she named "Laniākea O Kono." Originally, the quilter did not select the design for symbolic reasons, but after learning that taro once grew abundantly on the island of Hawai'i in the place where she and others were gathered for a Hawaiian quilt exhibition, she decided to name the quilt for the historic site. Considering the quilt's name and design, the artist then decided to present it to another famous quilter from the island of Hawai'i. Thus, the Hawaiian quilt expressed the quilter's commemorization of a historic location, a Hawaiian quilt exhibition, and a warm friendship—all at the same time.

Much of a Polynesian woman's definition of herself is tied to the roles she plays in interpersonal relationships. As seen from previously cited examples, women can express their bonds with others through their artistic decisions about tīfaifai. In addition to creating designs that express her personal feelings about another person, shared memories, or another's preference for certain designs, a Polynesian woman sometimes incorporates the name of the person for whom the tīfaifai is created and/or a sentiment, date, and signature. By adding such information in the form of applique, piecework, or embroidered

words, the makers of tīfaifai give personal expression to their ties with others. A woman's role as mother, grandmother, or friend, for example, is expressed when she integrates the name of a son or daughter, grandson or granddaughter, or a friend into a tīfaifai.

On the island of Rurutu, mothers often include a son or daughter's name in a tīfaifai designated to become a wedding present for that child. The women "write in" their children's baptismal and family surnames by creating the names in block letters with the small squares of cloth which they use to piece an entire tīfaifai design together. Though parents present the tīfaifai at their children's marriages, occasions upon which both men and women receive new marriage names, and it is ostensibly for both husband and wife, the name on the tīfaifai expresses the strong familial bonds which continue between an individual and his or her family. When a woman incorporates her daughter's name in a tīfaifai, she makes the continuing bond between a daughter and her parents explicit. Even though a woman is associated with her husband's surname and family and is usually addressed by her marriage name, her maiden name on the tīfaifai serves to remind others of her continuing bonds with her natal family.

In addition to expressing their ties with others, women communicate many other facets of their identities through their artistic choices. As indicated in other chapters, Polynesian women sometimes express their religious convictions, their identification with a group of islands, and their pride in their cultural heritage and history through the art form. Women utilize tīfaifai as versatile vehicles for communicating a wide variety of feelings. For example, Deborah (Kepola) U. Kakalia expressed her American patriotism in combination with her identification with Hawaiian cultural heritage by creating a "Beloved Flag" quilt (Figure 69) for the American Bicentennial. The artistic statement which she created in the quilt and its design served to communicate her pride in both her native culture and her nation.

To some extent, a woman's choice, whether to create an applique or a pieced tīfaifai, may reflect her decisions concerning work patterns, since women of many islands create pieced work in groups and applique work individu-

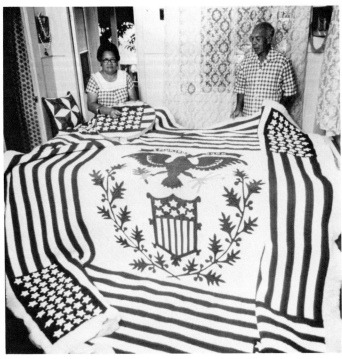

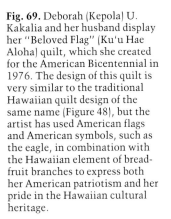

Fig. 69. Deborah (Kepola) U. Kakalia and her husband display her "Beloved Flag" (Ku'u Hae Aloha) quilt, which she created for the American Bicentennial in 1976. The design of this quilt is very similar to the traditional Hawaiian quilt design of the same name (Figure 48), but the artist has used American flags and American symbols, such as the eagle, in combination with the Hawaiian element of bread-fruit branches to express both her American patriotism and her pride in the Hawaiian cultural heritage.

ally. However, in most areas of eastern Polynesia a woman's choice in this regard is based on accepted regional aesthetics. Although women in the Cook Islands create both pieced and applique styles, in other areas of eastern Polynesia one style greatly predominates or exists by itself. In the contemporary milieu of interisland travel, exchange of information, and tīfaifai exhibitions, a woman's decision to make a pieced or applique tīfaifai usually reflects her self-identification as a member of a particular island group. Furthermore, regional variations in construction methods and artistic embellishments such as embroidery serve to differentiate regional styles of piecework and applique tīfaifai.

The third way in which women reflect and shape their identities by means of tīfaifai is communicated through their decisions about the way in which they are used. Although many eastern Polynesian women do not create tīfaifai, most of them own at least one, and usually several. Tīfaifai are part of a woman's personal wealth.

Many women strive to acquire a large number of them by making their own or by purchasing some made by others. Tīfaifai which are given to a man become the property of his wife in the sense that she cares for them and uses them as part of her household furnishings. A woman who knows how to design and construct tīfaifai can create her own wealth in tīfaifai. A woman who doesn't know how to make tīfaifai must either buy them, pay someone to create them for her, or rely on the good will of friends and relatives to provide them.

Because tīfaifai are so valuable, many women keep them under lock and key. Other women, however, display them on beds on a fairly regular basis as an indication of their wealth and in imitation of the Western women who decorate their homes with expensive furnishings. When a woman places tīfaifai on the beds in her house, she is displaying some of her most valuable possessions.

An impressive collection of tīfaifai may reflect a woman's status. Ministers' wives, for example, often own unusually large numbers as a result of their roles. Such women often accumulate tīfaifai as presents, through obligations to purchase them at church bazaars, or because of the necessity to furnish their homes in an appropriate manner for special occasions.

One of the most important ways in which women use tīfaifai is by decorating their homes with them on such special occasions as church holidays and family celebrations. A woman who has a sizeable collection of tīfaifai to display in her home, either through her own efforts or those of others, gains prestige as a consequence.

Tīfaifai are associated with women's roles in domestic contexts largely because the materials, tools, and skills a woman uses to make them reflect the traditional feminine role of creating clothing and household articles. Jones relates a story that illustrates the symbolic importance of women owning tīfaifai as an indication of their feminine roles in the domestic context. The story concerns a young Hawaiian woman who fell in love with a Chinese. Her parents opposed the marriage, but when at last her mother did consent, the mother made it clear that the daughter could have none of the calabashes or other Hawaiian things, including the quilts, intended for her.

The couple moved to Honolulu. The young wife was
ashamed before the other women because she had no quilt
for her bed. She purchased the necessary material but had
no pattern and was too humiliated to ask for one. Then
one night as she lay asleep she dreamed a pattern. The
dream was so vivid that it awakened her and, rising, she
cut the design direct from the material and basted it upon
the background before going back to sleep. In the morning
she was delighted with her handiwork. A friend who
helped her finish the quilt named it *Ka La'i o Pua* (The
Calm of Pua Lane). (Jones 1973:5)

The importance of tīfaifai ownership to many eastern
Polynesian women is echoed in a contemporary Raro-
tongan woman's declaration, "If I did not have any
tīvaevae, I would not be a woman!"

Most commonly, Polynesian women use tīfaifai in
expressing their roles in relation to others. By giving
tīfaifai to their friends and relatives, especially to their
children and grandchildren, women forge very strong
interpersonal bonds.

Even as group members, women who act as representa-
tives of an entire community or congregation in present-
ing tīfaifai to religious or political leaders are often able
to communicate their identities as individuals and to
express their personal sentiments. Good examples of
these practices are two special rituals that took place in
the Cook Islands. During a farewell ceremony held in
1978 on Rarotonga, a group of women gave a tīfaifai to
their late minister's widow (Figure 70). The women made
and presented the gift as a symbol of the bond which all
the members of the congregation felt with the widow. At
the same time, they were able to identify themselves as
members of the larger group and to express the sympathy
they felt for the widow.

In a special farewell ceremony for a minister and his
family on the island of Rarotonga, women of the congre-
gation created five tīfaifai to bestow in a special ritual
manner to the departing family. The family sat in a place
of honor, and the women carried the five unfolded tīfaifai
forward one at a time, placing each across the laps of the
family members (Figures 71 and 72). The last tīfaifai, a
special gift of the assistant minister's widow, was carried
forward in the same manner, but the donor had instructed

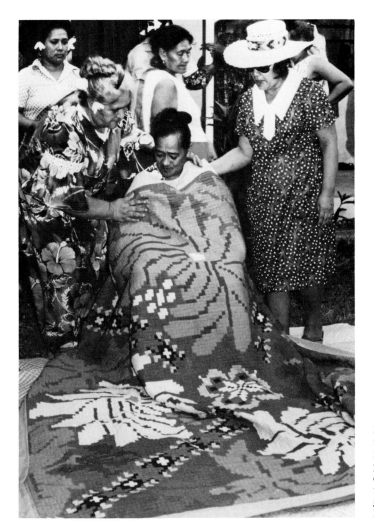

Fig. 70. Members of a congregation on the island of Rarotonga in the Cook Islands present a piecework tīfaifai to the widow of their late pastor during a farewell ceremony. Tīfaifai are often given to express emotions of love, respect, honor, and loss.

the women to place it over the heads of the family members for a few minutes before lowering it to their laps (Figure 73). The contrast of the last of the tīfaifai presentations with the other four distinguished it as a symbolic statement of the depth of the donor's sentiments.

Yet another way in which women use tīfaifai for shaping and reflecting their identities is through quilt and tīfaifai exhibitions and contests (Figures 74 and 75). These allow women to establish their reputations as artists and also provide a context within which women may sell their creations.

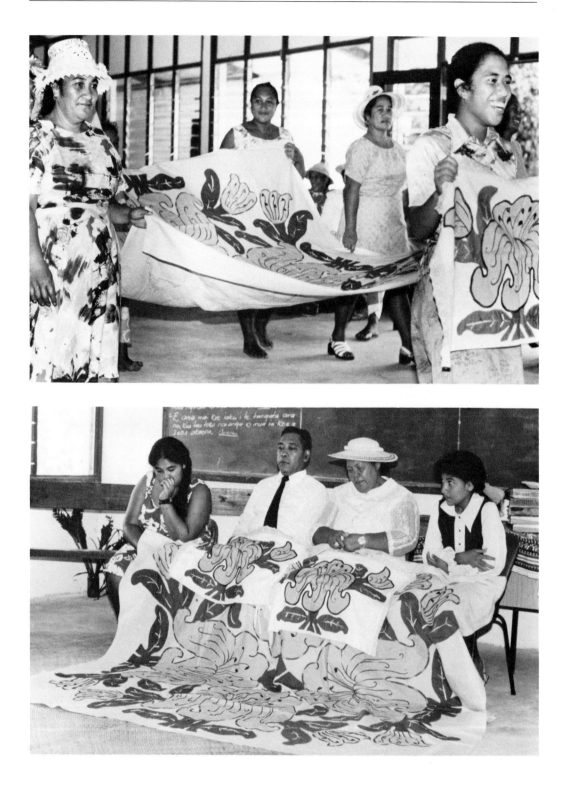

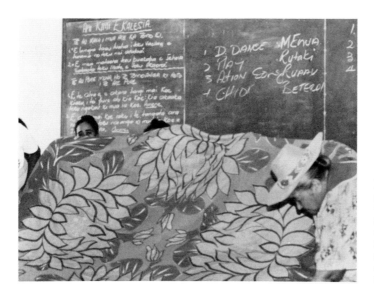

Fig. 73. A minister and his family are completely covered with an applique tīfaifai during a farewell ceremony in Rarotonga. The tīfaifai and its method of presentation served as a symbol of the deep-seated emotions of the assistant minister's widow.

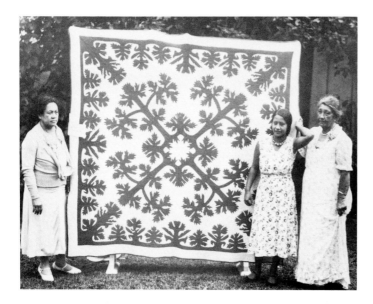

Fig. 74. "Lei of Mamo Feathers" (Lei Mamo). Applique, Hawaiian quilt. ca. 1930. This hand-sewn quilt, created by Dorothy Dudoit, the young woman on the right, took first prize in a Honolulu show. The quilts were judged by Helen Kaiua *(left)* and Martha Kamau *(right)* who were probably themselves expert quilters. Exhibitions and contests have encouraged Polynesian women to excel in the creation of tīfaifai and quilts.

Fig. 71 *(opposite, top).* Women church members present an applique tīfaifai and matching pillowcases to a Rarotongan minister and his family during a farewell ceremony in 1978. The display of the tīfaifai to honor the recipients is an important facet of the ceremony.

Fig. 72 *(opposite, bottom).* A Rarotongan minister and his family sit in seats of honor as members of their church present them with tīfaifai in a farewell ceremony. This tīfaifai with its matching pillowcases is only the first of five that were presented to the family.

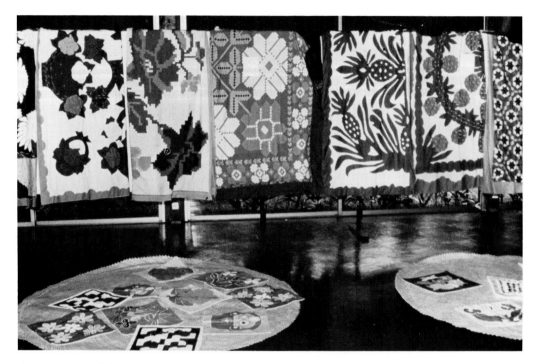

Fig. 75. Artisan exhibition
held in Pape'ete, Tahiti, in 1977.

Women of eastern Polynesia exercise a wide range of
options for self-expression in tīfaifai. They utilize tīfaifai
as both a means and an end in communicating their com-
plex, multifaceted identities. In the decisions they make
regarding work patterns, artistic choices, and uses for
tīfaifai, women actively express who they are, not only to
others but to themselves as well.

Afterword

This book began with a discussion of the difficulty of
translating the term *tīfaifai*. In a sense, the problem is not
so much in defining a term but in interpreting what Poly-
nesian tīfaifai and quilts mean to the people who make
and use them. One cannot truly understand tīfaifai and
quilts simply by photographing, labeling, and measuring
them. Opportunities to observe people making and using
tīfaifai and quilts, along with islanders' stories, anec-
dotes, and memories, provide a more complete under-
standing.

My most gratifying learning experiences were situa-
tions where people openly expressed their ideas and feel-
ings through the medium of a tīfaifai or quilt. During my
visit to the island of Ra'ivavae in the Austral Islands, I
stayed with the Protestant minister and his family for one
night. At the end of the evening, my host directed me to
the guest room. At the foot of the bed was a folded tīfaifai.
The presence of the tīfaifai was not a response to the
interest I expressed in the art form, but rather a gesture of
respect and honor that would be given to any guest in the
family's home. Realizing that, I felt very honored indeed.

Selected Bibliography

Akana, Elizabeth A.
 1981. *Hawaiian Quilting—A Fine Art*. Honolulu: Hawaiian Mis-
 sion Children's Society.

Altonn, Helen
 1975. "Beautiful Patterns Stitched with Love." *Honolulu Star-
 Bulletin*, September 8, pp. B1 and B4.

Bacon, Lenice Ingram
 1973. *American Patchwork Quilts*. New York: William Morrow.

Barrère, Dorothy B.
 1965. "Hawaiian Quilting, A Way of Life." *Conch Shell* 3 (2):
 14–34.

Beaglehole, Ernest
 1957. *Social Change in the South Pacific: Rarotonga and Aitutaki*.
 London: Allen and Unwin.

Bligh, William
 1937. *The Log of the* Bounty. 2 vols. London: Golden Cockerel
 Press.

Butterworth, F. Edward
 1977. *Roots of the Reorganization, French Polynesia*. Indepen-
 dence, Missouri: Herald Publishing Co.

Christian, F. W.
 1920. "Cutting the Adult Boys' Top Knot." *Journal of the Polyne-
 sian Society* 29:104.

Christiansen, Barbara
 1961. "Bark Cloth or Tapa, Its Past and Present Uses in Selected
 Areas of the Pacific in Relation to Social Change." Ph.D. dis-
 sertation, Department of Home Economics, Utah State Uni-
 versity.

Colby, Averil
 1965. *Patchwork Quilts*. New York: Charles Scribner's Sons.

Cooke, Mary
 1976. "History Will Make It Sew." *Honolulu Advertiser*, June 9.

Cumming, C. F.
 1877. *A Lady's Cruise in a French Man-of-War*. 2 vols. London:
 Blackwood and Sons.

Cuzent, M. G.
 1860. Iles de la Société. Rochefort: Imprimerie chez Thèze.

Danielsson, Bengt
 1953. *Raroia, Happy Island of the South Seas*. Translated by F. H.
 Lyon. New York: Rand McNally.
 1966. *Gauguin in the South Seas*. Translated by Reginald Spink.
 New York: Doubleday.

Dumas, Alexandre
 1858. *Journal de Madame Giovanni en Australie, aux Isles Mar-
 quises, à Taiti*. . . . Paris: Dufour, Mulat, et Boulanger.

Ellis, William
 1831. *Polynesian Researches*. 4 vols. London: Fisher, Son, and
 Jackson. Reprinted 1969 by Charles E. Tuttle Co., Rutland,
 Vermont.

A Festival of Fibers: Masterworks of Textile Art from the Collection of the Honolulu Academy of Arts.
 1977. Catalogue from "A Fiftieth Anniversary Exhibition," Oct. 14–Nov. 20. Honolulu: Honolulu Academy of Arts.

Fisk, Marcella
 1945. "Hawaiian Quilts." *Paradise of the Pacific* 57 (2): 17–20.

Forster, Johann Reinhold
 1778. *Observations Made during a Voyage Round the World on Physical Geography, Natural History, and Ethic Philosophy.* London: G. Robinson.

Graburn, Nelson H., ed.
 1976. *Ethnic and Tourist Arts: Cultural Expressions from the Fourth World.* Berkeley: University of California Press.

Henry, Teuira
 1928. *Ancient Tahiti.* Bernice P. Bishop Museum Bulletin 48. Honolulu: Bishop Museum Press.

Huguenin, Paul
 1902. "Raiatea la Sacrée." *Société Neuchateloise de Géographie, Bulletin* 14:5–270.

Innes, Helen
 1957. *Your Hawaiian Quilt. "How-to-make-it."* Honolulu: Hawaii Home Demonstration Council.

Jones, Stella M.
 1930. *Hawaiian Quilts.* Honolulu: Honolulu Academy of Arts.
 1973. *Hawaiian Quilts.* 2nd ed. Honolulu: Daughters of Hawaii, Honolulu Academy of Arts, and Mission Houses Museum.

Kaeppler, Adrienne L.
 1979. "A Survey of Polynesian Art." In *Exploring the Visual Art of Oceania,* edited by Sidney M. Mead, pp. 180–191. Honolulu: The University Press of Hawaii.

Kamakau, Samuel Manaiakalani
 1964. *Ka poʻe kahiko: The People of Old.* Bernice P. Bishop Museum Special Publication 51. Honolulu: Bishop Museum Press.

Kooijman, Simon
 1972. *Tapa in Polynesia.* Bernice P. Bishop Museum Bulletin 234. Honolulu: Bishop Museum Press.
 1973. "Tapa Techniques and Tapa Patterns in Polynesia: A Regional Differentiation." In *Primitive Art and Society,* edited by Anthony Forge, pp. 97–112. New York: Oxford University Press.

Kuykendall, Ralph S.
 1968. *The Hawaiian Kingdom.* Vol. 1. Honolulu: University of Hawaii Press.

Kyser, Pat Flynn
 1980. "Pieces and Patches." *Quilt World* 5 (2): 4–6; 5 (3): 16–19.

Lemaitre, Yves
 1973. *Lexique du Tahitien Contemporain.* Paris: Office de la Recherche Scientifique et Technique Outre-Mer.

Leonard, Anne, and John Terrell
 1980. *Patterns of Paradise.* Chicago: Field Museum of Natural History.

Malo, David
 1903 *Hawaiian Antiquities.* Translated by N. B. Emerson.
 [1898]. Honolulu: Hawaiian Gazette Co.

Mauer, Daniel
 1970. *Protestant Church at Tahiti.* Translated by Alec Ata. Société
 des Océanistes, Dossier 6. Paris: Nouvelles Editions Latines.

McCracken, Sally
 1972. "Hawaiian Quilts." *Creative Crafts*, October, pp. 25–29.

McFeeley, Peggy
 1973. "Tapa Design." In *Dimensions of Polynesia*, edited by
 Jehanne Teilhet, pp. 135–147. San Diego: Fine Arts Gallery of
 San Diego.

Nelson, Cyril I., ed.
 1978. *The Quilt Engagement Calendar.* New York: E. P. Dutton.

Nelson, Cyril I., and Carter Houck
 1982. *Quilt Engagement Calendar Treasury.* New York: E. P.
 Dutton.

Newman, Thelma R.
 1974. *Quilting, Patchwork, Applique and Trapunto.* New York:
 Crown Publishers.

Oliver, Douglas
 1974. *Ancient Tahitian Society.* 3 vols. Honolulu: The University
 Press of Hawaii.

O'Reilly, Patrick
 n.d. *Dancing Tahiti.* Translated by Alec Ata. Société des
 Océanistes, Dossier 22. Paris: Nouvelles Editions Latines.
 1959. "Note sur les 'Ti Fai Fai' Tahitiens." *Journal de la Société des
 Océanistes* 15:165–177.
 1969. *Les Photographes à Tahiti et Leurs Oeuvres 1842–1962.*
 Société des Océanistes. Paris: Musée de l'Homme.
 1975. *Tahiti au Temps des Cartes Postales.* Paris: Nouvelles Edi-
 tions Latines.

Peto, Florence
 1949. *American Quilts and Coverlets.* New York: Chanticleer
 Press.

Plews, Edith Rice
 1973. *Hawaiian Quilting on Kauai.* An Address Given to the Moki-
 hana Club at Lihue, Kauai, March 1, 1933. Kauai Museum
 Publication.

Pukui, Mary Kawena, and Samuel H. Elbert
 1971. *Hawaiian Dictionary.* Honolulu: University of Hawaii Press.

Robertson, George
 1948. *The Discovery of Tahiti: A Journal of the Second Voyage of
 H.M.S. "Dolphin" Round the World, 1766–1768.* Edited by
 Hugh Carrington. Second Series, vol. 98. London: Hakluyt
 Society.

Rose, Roger G.
 1980. *Hawai'i: The Royal Isles.* Bernice P. Bishop Museum Special
 Publication 67. Honolulu: Bishop Museum Press.

Safford, Carleton L., and Robert Bishop
 1972. *America's Quilts and Coverlets.* New York: E. P. Dutton.

Savage, Stephen
 1962. *A Dictionary of the Maori Language of Rarotonga.* Wel-
 lington, New Zealand: Department of Island Territories.

Singletary, Milly
 1976. *Hawaiian Quilting as an Art.* Instructed by Kepola U. Kaka-
 lia. Honolulu: Privately printed by D. U. K.

Smith, Thomas
 1825. *The History and Origin of the Missionary Societies.* Vol. 2.
 London: Thomas Kelly and Richard Evans.

Stevens, Napua
 1971. *The Hawaiian Quilt.* Honolulu: Service Printers.

Tamahori, Maxine J.
 1963. "Cultural Change in Tongan Bark-Cloth Manufacture." Mas-
 ter's thesis, Department of Anthropology, University of
 Auckland.

Taylor, Lois
 1970. "Hawaiians Kept the Quilt and Gave Away the Land." *Hono-
 lulu Star-Bulletin*, October 3, p. A6.

Thurston, Lucy G.
 1882. *Life and Times of Mrs. Lucy G. Thurston.* Ann Arbor, Michi-
 gan: S. C. Andrews.

Troxler, Gale Scott
 1971. *Fijian Masi: A Traditional Art Form.* Greensboro, North
 Carolina: The Piedmont Press.

T'Serstevens, A.
 1950. *Tahiti et Sa Couronne.* 3 vols. Paris: Editions Albin Michel.

Vernier, Charles
 1948. *Tahitiens d'Hier and d'Aujourd'hui.* Paris: Société des Mis-
 sions Evangéliques.

Wilson, James
 . 1966. *A Missionary Voyage to the Southern Pacific Ocean 1796–
 1798.* Graz: Vienna Akademische Druck u. Verlagsanstalt.

Illustrations and Credits

Figures

1. "Grapes" (Vine), Society Islands, p. 4
2. "Pinks" (Oeillet), Society Islands, p. 5
3. " 'Ape Leaf" ('Ape), Society Islands, p. 6
4. "Hibiscus" ('Auti), Society Islands, p. 6
5. "Hibiscus" (Kaute), Cook Islands, p. 8
6. "Lily" (Lili), Cook Islands, p. 8
7. Detail of tīvaevae tāorei, Cook Islands, p. 9
8. "Turtle Carapace Turtle" (Paka 'Onu 'Onu), Cook Islands, p. 10
9. "Ordinary" (Ordinaire), Austral Islands, p. 13
10. "Panapana Fish" (I'a Panapana), Austral Islands, p. 14
11. "Crown of Queen Liliuokalani" (Kalaunu O Liliuokalani), Hawaiian Islands, p. 16
12. "Gentle Hawaiian Breeze," Hawaiian Islands, courtesy of Elizabeth A. Akana, p. 17
13. Comparison of Hawaiian applique quilts and Society Islands applique tīfaifai, p. 18
14. Hawaiian quilter, photo by Nancy Bannock, courtesy of State of Hawaii Department of Accounting and General Services, p. 19
15. Detail of " 'Ilima Lei" (Lei 'Ilima), Hawaiian Islands, p. 19
16. "Tahitian Flower" (Tiare Tahiti), Society Islands, pp. 24–25
17. Woman beating bark cloth, engraving by J. Alphonse Pellion, by permission of Bernice P. Bishop Museum, p. 28
18. Historical Hawaiian quilting designs, adapted by Joy Dabney from Jones 1973:12, by permission of Honolulu Academy of Arts, p. 34
19. Patterns on Hawaiian bark cloth beaters, by permission of Bernice P. Bishop Museum, p. 35
20. Hawaiian piecework quilts on the floor of Our Lady of Peace Cathedral, by permission of Bernice P. Bishop Museum, p. 35
21. "Star" (Etu), Society Islands, p. 36
22. "Star of Bethlehem," New York, from *The Quilt Engagement Calendar*, copyright © 1978 by Cyril I. Nelson, reproduced by permission of the publisher, E. P. Dutton, Inc., p. 37
23. "Princess Feather," Pennsylvania, from *The Quilt Engagement Calendar*, copyright © 1978 by Cyril I. Nelson, reproduced by permission of the publisher, E. P. Dutton, Inc., p. 43
24. "Breadfruit" (Ka 'Ulu), Hawaiian Islands, courtesy of Rosalie Lailana Kekona and son, Tommy Dean Kekona, p. 43
25. "Album Quilt," Maryland, from *The Quilt Engagement Calendar Treasury*, p. 148, copyright © 1982 by Cyril I. Nelson and Carter Houck, reproduced by permission of the publisher, E. P. Dutton Inc., p. 44
26. "Grapevine" (Ke Kumu Waina), Hawaiian Islands, by permission of Honolulu Academy of Arts, gift of Mr. and Mrs. Richard A. Cooke, 1927, HAA 2589, p. 45
27. Crib quilt, New York, from *The Quilt Engagement Calendar Treasury*, p. 29, copyright © 1982 by Cyril I. Nelson and Carter Houck, reproduced by permission of the publisher, E. P. Dutton, Inc., p. 45
28. "Press Gently" (Kaomi Mālie), by permission of Honolulu Academy of Arts, gift of Mrs. Albert Wilcox, 1927, HAA 2272, p. 46
29. Western applique quilt, from *The Quilt Engagement Calendar Treasury*, p. 147, copyright © 1982 by Cyril I. Nelson and Carter Houck, reproduced by permission of the publisher, E. P. Dutton, Inc., p. 47
30. "Crowns and Maile Lei" (Na Kalaunu Me Ka Lei Maile), Hawaiian Islands, courtesy of Daughters of Hawaii, p. 48
31. Tahitian bark cloth, copyright by Collection National Museum of Ethnology, Leiden, the Netherlands, #360–7007, p. 48
32. "Serrated 'Ape Leaf" ('Ape Mahaehae), Society Islands, p. 49
33. Hawaiian bark cloth, by permission of Field Museum of Natural History, Chicago, Illinois, #64868, p. 50
34. "Niumalu Beauty" (Nani O Niumalu) or "Nāwili Beauty" (Nani O Nāwili), by permission of Honolulu Academy of Arts, gift of Mrs. Dora Isenberg, 1940, HAA 4831, p. 51
35. Bed cover *(kapa moe)*, Hawaiian Islands, by permission of Bernice P. Bishop Museum, Seth Joel, p. 52
36. Tīfaifai from the island of Takaroa, Tuamotu Islands, p. 54
37. "An Offering before Captain Cook," by permission of Bernice P. Bishop Museum, P. Gilpin, p. 56
38. High Commissioner of French Polynesia Charles Schmitt wrapped in a tīfaifai, courtesy of Claude Claverie, p. 56
39. Presentation of tīfaifai to the Duke and Duchess of Kent, courtesy of Johnsons' Photographic Studios, p. 57
40. Tīfaifai at birthday celebration in Cook Islands, courtesy of Rohea Tangaroa, p. 58
41. Rarotongan hair-cutting ritual, courtesy of Johnsons' Photographic Studios, p. 60
42. Sketch of "feast house" in Society Islands, p. 61
43. Applique tīfaifai decorate a "feast house" in Society Islands, p. 62
44. Wedding couples in Society Islands, photo *b* courtesy of Jeannette Ganivet, p. 63
45. Women of Rurutu about to wrap tīfaifai around a marrying couple in Austral Islands, p. 65
46. A woman and her granddaughters wrapped in a tīfaifai, p. 66
47. "Kapa—A Study," Hawaiian

Index

About the Author

Joyce D. Hammond *(right)* holds a Ph.D. in anthropology from the University of Illinois. She conducted her doctoral research on Polynesian tīfaifai and quilts in 1977-1978, and has since served as guest curator for several Polynesian tīfaifai and quilt exhibits. Dr. Hammond has also served as a consultant in Polynesian arts for the Utah Arts Council. She has taught at a number of institutions, including the Field Museum of Natural History, and is currently an associate professor of anthropology at Western Washington University in Bellingham, Washington.

HAWAII Production Notes

This book was designed by Roger Eggers.
Composition and paging were done on the
Quadex Composing System and typesetting
on the Compugraphic 8400 by the design
and production staff of University of
Hawaii Press.

The text and display typeface is Trump.

Offset presswork and binding were done by
Malloy Lithographing, Inc. Text paper is
Glatco coated matte, basis 70.